ROYAL ACADEMY ILLUSTRATED 2011

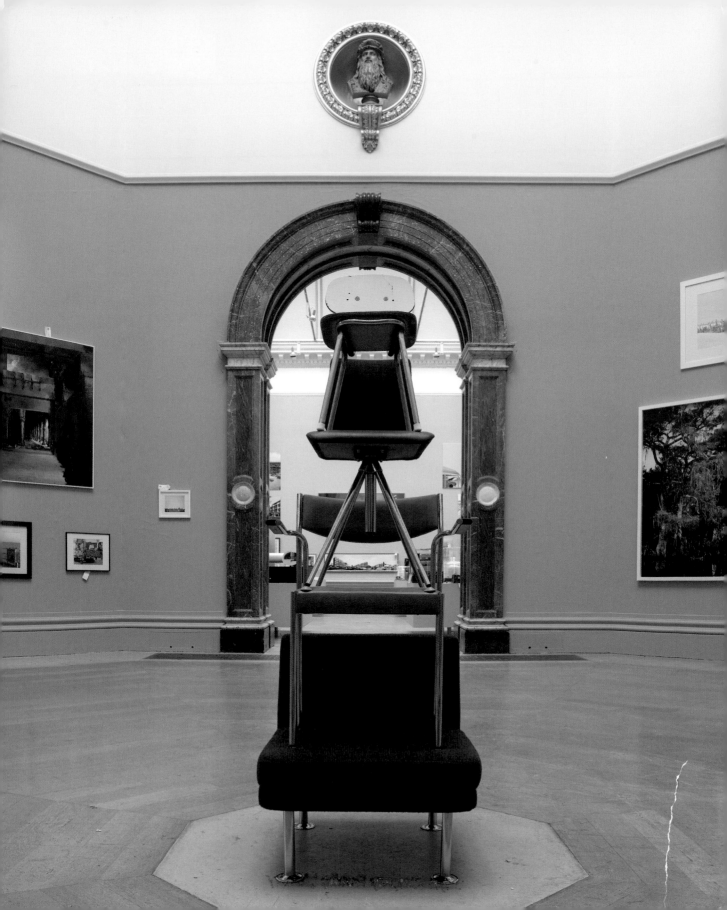

A Selection from the 243rd Summer Exhibition
Edited by Christopher Le Brun RA

ROYAL ACADEMY ILLUSTRATED 2011

SPONSORED BY

ROYAL ACADEMY OF ARTS

Contents

Sponsor's Foreword

Insight Investment is delighted, as lead sponsor, to continue its association with the Royal Academy of Arts and the artistic talent for which the Summer Exhibition is widely renowned.

Insight is a specialist asset manager at the forefront of building investment solutions designed specifically to meet its clients' evolving needs. Launched in 2002, we have grown to become one of the largest asset managers in the UK, winning industry recognition for our investment capabilities. Our investment platform has been built to give complete flexibility across a broad range of asset classes, an essential tool in providing tailored client solutions. With well-resourced, highly skilled teams, we aim to achieve consistent and repeatable returns. We cover the entire risk/return spectrum, offering our clients absolute or relative return performance benchmarks.

Insight's ongoing partnership with the Royal Academy is driven by two shared values: innovation and creative thinking. Innovation is key to the development of our investment capabilities and as leaders in our particular areas of expertise we continue to look for opportunities to expand our business to reach new clients and countries. For Insight, creative thinking is about breaking ground, challenging convention and thinking boldly and differently in everything we do, qualities that are in abundance at this year's Summer Exhibition.

This is now our sixth year of sponsorship and we very much hope that visitors to the exhibition, along with our clients, business partners and colleagues, will find new sources of inspiration in the works on display.

More insight. Not more of the same.

Abdallah Nauphal
Chief Executive Officer

Introduction
Richard Cork

Visitors may be surprised to discover, as they walk into the initial room of the Royal Academy's 243rd Summer Exhibition, that the images surrounding them are all photographic. They give the show a provocative beginning, in a space dominated by Cindy Sherman's monumental image of a red-cheeked woman grinning at us eerily from the darkness and, on the neighbouring wall, Darren Almond's immense and haunting photograph of a swampy landscape, which pitches us into a mysterious world. For the first time in the Summer Exhibition's long history, the ever-burgeoning power of photography provides an unexpected introduction on the walls of the Wohl Central Hall.

But Christopher Le Brun, the main co-ordinator of this year's show, is equally excited about his combative approach to the epic space within Gallery III. 'There are two ways of showing paintings,' he explains with a defiant smile. 'One is the classic orthodox hang with lots of space around every single piece. But here it's like a battle of the paintings – forty big pictures on one wall alone!' With great daring, Le Brun also took the decision to paint Gallery III a warm, dark grey. 'It makes the exhibits sing out at you,' he declares, pointing to a robust and immense work on the end wall by the eminent Danish painter and poet Per Kirkeby. 'He was really pleased to be invited,' says Le Brun, praising Kirkeby's 'thoughtful response to painting, with very subtle tones and harmonies'. At another extreme, the north wall of Gallery III erupts in the centre with Keith Tyson's highly reflective, apocalyptic painting *Deep Impact*. Tyson, who won the Turner Prize in 2002, here produces a twenty-first-century vision of a world in flames. Le Brun tells me that 'everyone who sees Tyson's painting says: "John Martin!"' And Tyson undoubtedly shares Martin's nineteenth-century obsession with flaring, end-of-the-world explosiveness.

By no means everything on view in Gallery III boasts such enormous dimensions. Ben Levene, who sadly died in September 2010, is represented by a number of delicate still-lifes and landscapes throughout the changing seasons. And Paul Huxley, in a very impressive painting called *Proteus X*, explores a fascinating dialogue between a curvilinear black-and-white form and rectilinear blocks of colour. Le Brun's own painting, simply called *Trust*, relies for its poignant impact on images of vulnerable, elongated trees. Although this landscape was 'entirely made up', he explains that 'it is reliant on memory and association but without narrative – a modern classicism'. Tony Bevan, who helped Le Brun to curate Gallery III, candidly admits: 'I found it the most difficult exhibition I've ever had to hang in my life! But I like the look of it, because that's the nature of an open submission selected from an incredible total of 12,000 entries.'

Michael Craig-Martin, who has curated another major room in the Summer Exhibition, adopted the opposite approach. 'Normally, the Royal Academicians are hidden among everyone else,' he says. 'I wanted to show their range and quality by focusing for the first time on RAs only, because there are lots of new ones and nobody

Hughie O'Donoghue RA
Cumae: Labyrinth
Oil
244 × 300 cm

quite realises that they have all arrived here.' Craig-Martin is particularly determined to highlight the presence of recently elected women: Tacita Dean, Tracey Emin, Lisa Milroy, Cornelia Parker, Fiona Rae, Jenny Saville, Gillian Wearing and Alison Wilding. Their work – ranging from painting and sculpture to photography and neon – gives his room an extraordinary intensity. 'I think there should be far more women RAs,' says Craig-Martin. 'It's no longer acceptable that we have so few. I want to see a far broader representation of the art world among RAs. So I hope this room is a start to inaugurating change.'

Craig-Martin has also included male sculptors as outstanding as Tony Cragg, Richard Deacon, Antony Gormley, Anish Kapoor, Michael Landy, Richard Long, David Mach, Michael Sandle, Richard Wilson and Bill Woodrow. Combined with work by some of the RA's finest painters – Tony Bevan, Gary Hume, Allen Jones, Christopher Le Brun, Humphrey Ocean and Joe Tilson – the exhibits in this room have an enormously varied and stimulating impact. 'There isn't a dud work here,' declares Craig-Martin. 'I said to each of the artists: "I want something really special from you," and they all became competitive when they realised who else would be included. That's why they put their best feet forward.' So too did Craig-Martin, whose haunting painting shows the word FATE interlinked ominously with a pink gate. 'I always try to find unexpected correlations between words and images', he explains, 'and lock them together in a special way.'

Not to be outdone, Jeff Koons responded to the Royal Academy's invitation by sending in a sculpture called *Coloring Book*. Placed outside in the Annenberg Courtyard and rising eighteen feet towards the sky, this joyful stainless-steel sculpture captures the abandon of children's art. Inspired by 'a line drawing of Piglet from *Winnie the Pooh* that I found in a colouring book', Koons has here created one of his most exuberant pieces. And playfulness persists in Martin Creed's sculpture occupying the floor of the Wohl Central Hall. Four chairs are balanced on top of each other as they ascend towards the ceiling, asserting their defiance while struggling to avoid collapse. But Anselm Kiefer explores a very different mood in the Large Weston Room. His enormous *Aurora* is far more sinister than Koons's sculpture. Forever meditating on the aftermath of the Second World War, Kiefer here shows a submarine-like form floating in a mass of water. Stained, splashed and battered, it hangs down from the thinnest of wire supports. Yet it looks lethal as well.

Frank Auerbach, who is also exhibiting in the Large Weston Room, escaped from Nazi Germany as a child. But his family did not evade persecution, and a sense of underlying tragedy can be detected in Auerbach's head of a man displayed here. Nearby, Tony Bevan's incisive *Self-portrait after Messerschmidt*, executed in acrylic and charcoal, has a similar brooding power. But by no means everything in this room is ominous in mood. Edmund de Waal's cabinet shelves are punctuated by cool, minimal forms guaranteed to calm us down. Mimmo Paladino's large painting *Fuga in Egitto* is filled with vitality. And James Hugonin's deft painting consists of close-toned colours inspired, perhaps, by the luminosity of Britain's northeast coast, near Lindisfarne. Adrian Berg's landscape is soothing, while Stephen Chambers's sensual and pellucid paintings celebrate the infinite fascination of still-life.

Even so, one big canvas here points us in a far more disturbing direction. Executed by Stephen Farthing, who has hung the Large Weston Room, *Gaddafi's Tent* is a very timely painting. Here, while a group of fighter planes is poised for take-off outside, the hardware inside the tent testifies to the Colonel's appetite for incessant, devious planning. The overall mood is summed up by the words from the song 'Strange Fruit', made famous by Billie Holiday. Floating through the tent, they include the line 'the bulging eyes and twisted mouth'.

The images in the Small Weston Room are more reassuring. Olwyn Bowey's selection of work focuses on landscapes, still-life and unpopulated interiors. Very few images of people can be seen

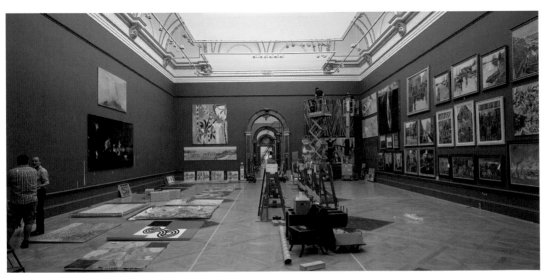

Left:
Installation of
Gallery III in progress

Opposite:
Jeff Koons Hon RA
Coloring Book, installed in
the Annenberg Courtyard

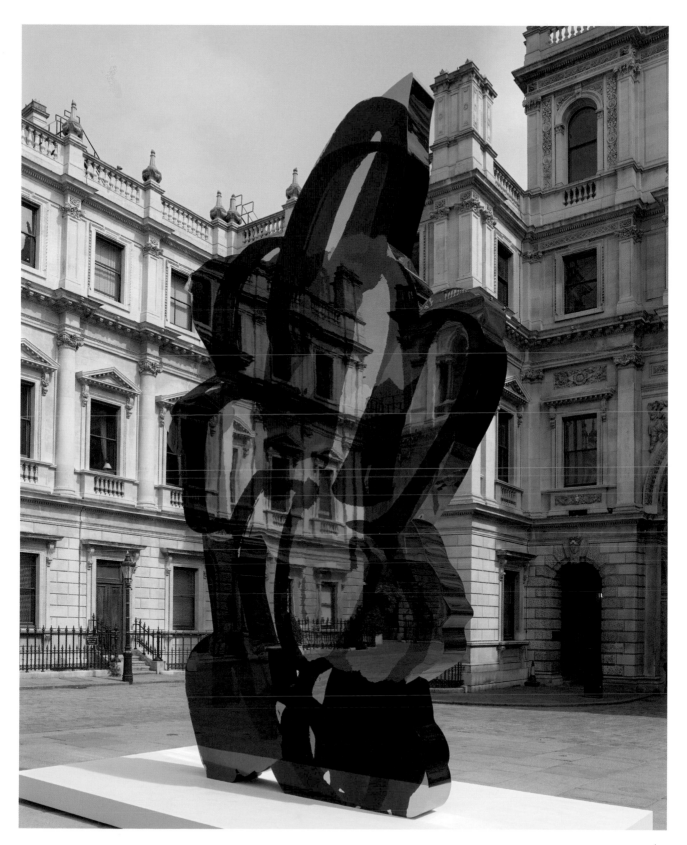

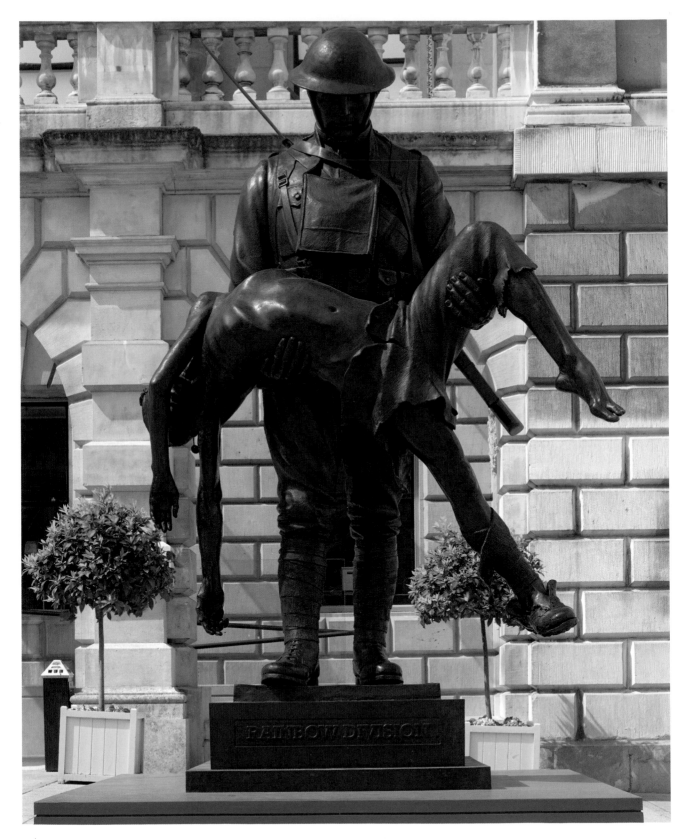

here, and Bowey herself shows a sympathetic painting of fragile sunflowers. David Tindle stands out with his limpid domestic scenes, and so does Elizabeth Blackadder's watercolour of carnations, iris and a patterned tile. Her flower-piece should be compared with Anthony Green's in Gallery IX, where he paints *Three Vases of Montbretia* with exemplary precision and verve. But back in the Small Weston Room, David Holmes's ghostly ship is far more other-worldly, while P. J. Crook pitches us into urban conflict with a crowd of protesters brandishing banners with slogans like 'Freedom'.

Chris Orr, who has hung all the prints in Galleries I and II, blithely declares that 'the text for these two rooms is art, greed and lust!' He points to images of dancing women by Allen Jones, as well as Michael Craig-Martin's prints in which the words GREED and LUST are spelled out in capital letters. But plenty of alternative human urges can be discovered in other prints. Barbara Rae's fiercely impulsive landscapes are distilled and structural, making us aware of history as well as present-day reality. Jim Dine concentrates on a paintbrush and wall-saws. Humphrey Ocean's freely handled aquatint celebrates a *China Dog*, while Gillian Ayres's sunlit and technically complex images have titles as generative as *The Seeds that Woke the Clay*. Adam Dant's gold-leaf exhibit *New York Public Library (Arcadia)* shows beams of sunlight pouring through the roof and transforming everything in sight.

Michael Sandle, who has hung Gallery VIII, never hesitates to explore the horror of war. James Butler's *Rainbow Division Memorial*, an elegiac sculpture of a soldier carrying the body of an emaciated victim, is installed in the Annenberg Courtyard and represented in this gallery by a study and a maquette, alongside Tim Shaw's dramatic wax sculpture of a man on fire, running for his life in Iraq. Equally alarming is Brian Taylor's Rodinesque naked figure of *The Executioner*, while Paul Wager has made a requiem sculpture with swords and driftwood on a marble base.

James Butler MBE RA
Rainbow Division Memorial,
installed in the Annenberg
Courtyard

But Sandle has also included Stephen Cox's two mysterious *Oracle* carvings, as well as hailing the vitality of abstraction in Phillip King's fascinating *Blue Slicer*.

Tess Jaray has hung Gallery V according to very different principles. 'This is a room only for people who are sensitive, intelligent and thoughtful,' she says. 'No one else will enjoy it: the works are delicate, subtle and rich.' Her own work certainly fulfils this aim, and she has orchestrated the other exhibits with ingenious flair. These were mostly sent-in rather than provided by RAs, and one of them, Olu Shobowale's *Coffin 'To Die For'*, particularly stands out: decoratively lined with animal bones, this sarcophagus is appealing despite its macabre form.

John Wragg has achieved a similar feat in Gallery IV, where Ann Christopher stands out with her set of eight interlinked images called *Marks on the Edge of Space*. Here, elongated and curving forms seem to emerge from water, hang down over fields and project upwards into space. Her sculpture is equally eloquent, and elsewhere in this room John Maine displays his powerful *Definition in Five Stages*, ranging crisply defined polygonal granite forms along a white base. Nearby, David Nash exhibits a severed tree trunk, pierced with burnt holes and hollowed out so that we can peer right through its blackened interior.

Piers Gough and Alan Stanton, who have co-ordinated the Architecture Room, both derived great stimulus from the context of the Summer Exhibition. As Stanton enthusiastically points out: 'It encourages us to think about relationships between art and architecture – sculptural, conceptual and photographic.' They can all be discerned here, in a display that affirms the resilience of architecture at a time of severe economic recession. Exceptional drawings by students, including a gothic skeletal structure by Maria-Eleni Tsolka, show the emergent generation at its best. But senior talents are impressive, too. Foster + Partners show a bold yet admirably respectful project for La Porte Romaine, Nîmes. Rogers and Partners have sent in an acrylic white model called *Miami Tower*, surging upwards with streamlined assurance. A photograph of Richard MacCormac's Kendrew Quadrangle at St John's College, Oxford, is equally satisfying. And the President of the Royal Academy, Nicholas Grimshaw, shows a highly sculptural model for his Crossrail project as well as an enticing model of the Cutty Sark Conservation Project.

The admirable Maggie's Cancer Caring Centres, now being built next to NHS hospitals all over Britain, are represented here by new projects. Chris Wilkinson shows a crisp, dynamic pencil drawing of the new Maggie's in Oxford, while Piers Gough exhibits a beguiling ceramic model of his Maggie's in Nottingham, where it is surrounded by trees. He sums up the feeling behind this whole room by explaining that architects are 'so pleased to be in a major art show. Architecture is an art, and we owe it to the public to produce exhilarating work.'

WOHL CENTRAL HALL

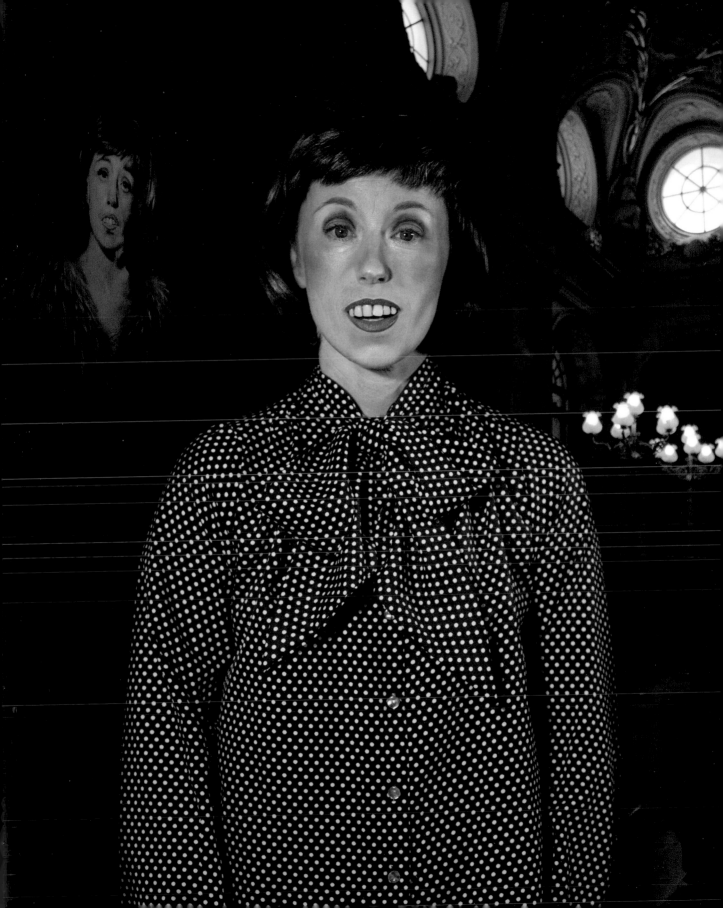

Darren Almond
Fullmoon@Autumnal Cypress
C print
180 × 180 cm

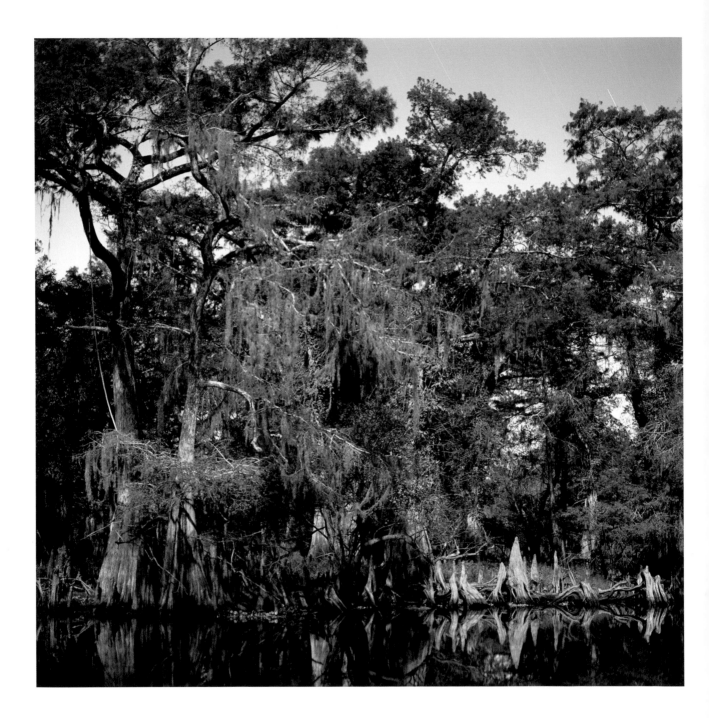

Martin Creed
Work no. 998
Mixed media
H 187 cm

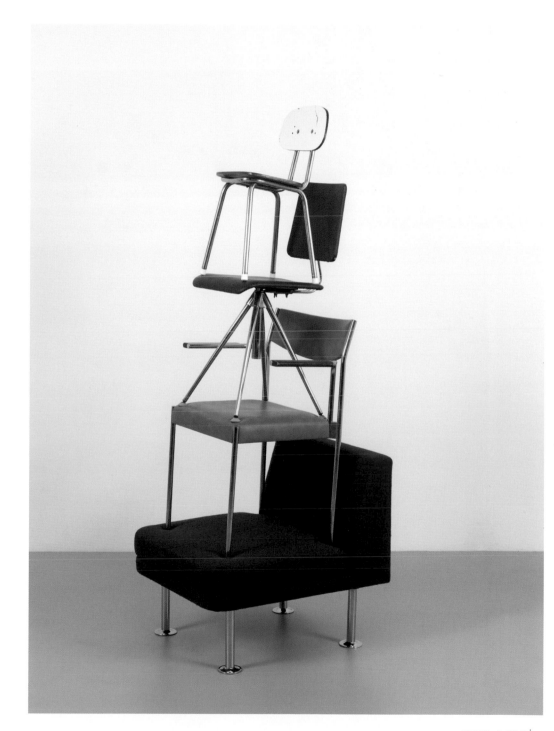

Garry Fabian Miller
Cobolt (IV)
Digital C–type print
122 × 152 cm

Cornelia Parker OBE RA
Self–portrait with Budget Box (Red and Black) (detail)
Photographic diptych
75 × 61 cm

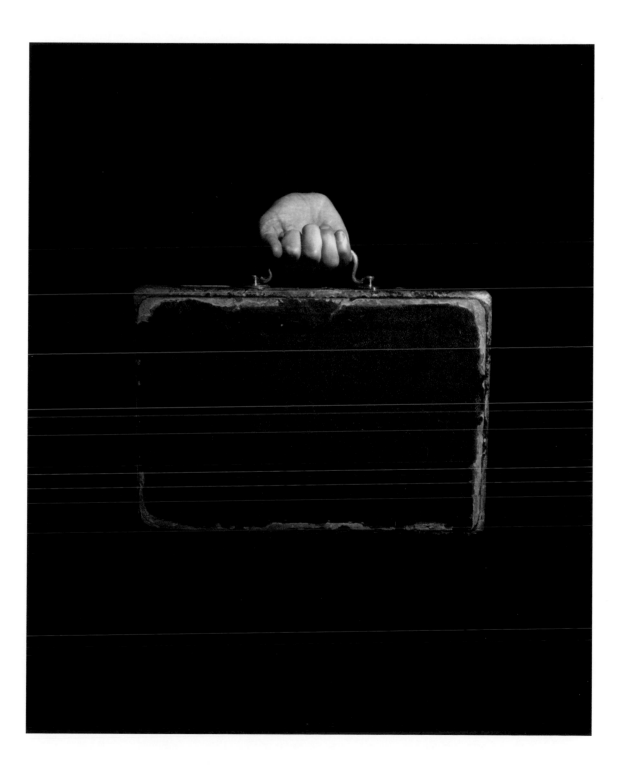

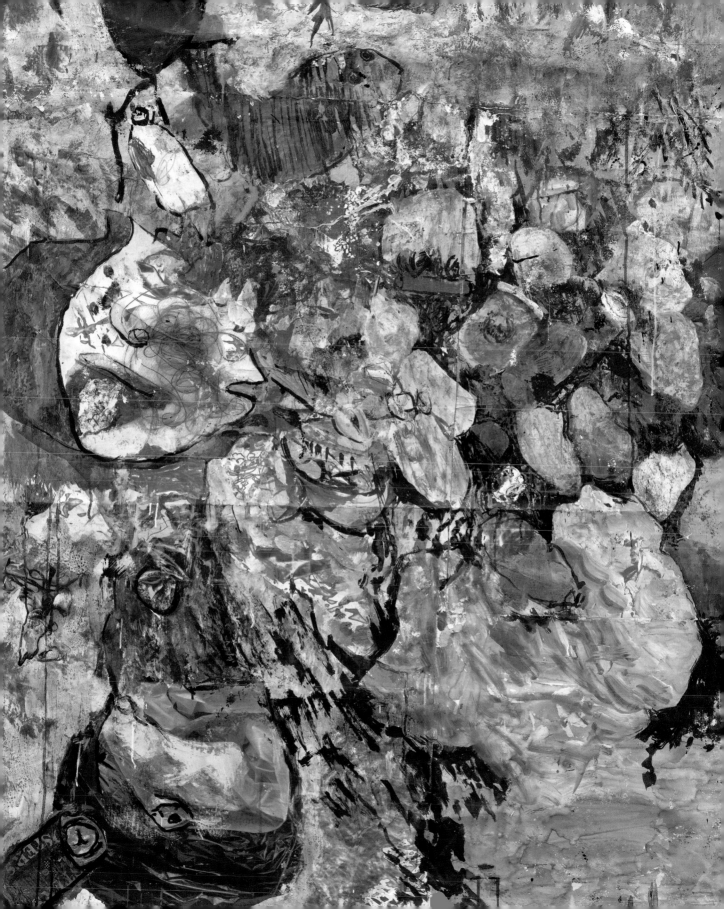

Keith Tyson
Deep Impact
Mixed media
198 × 398 cm

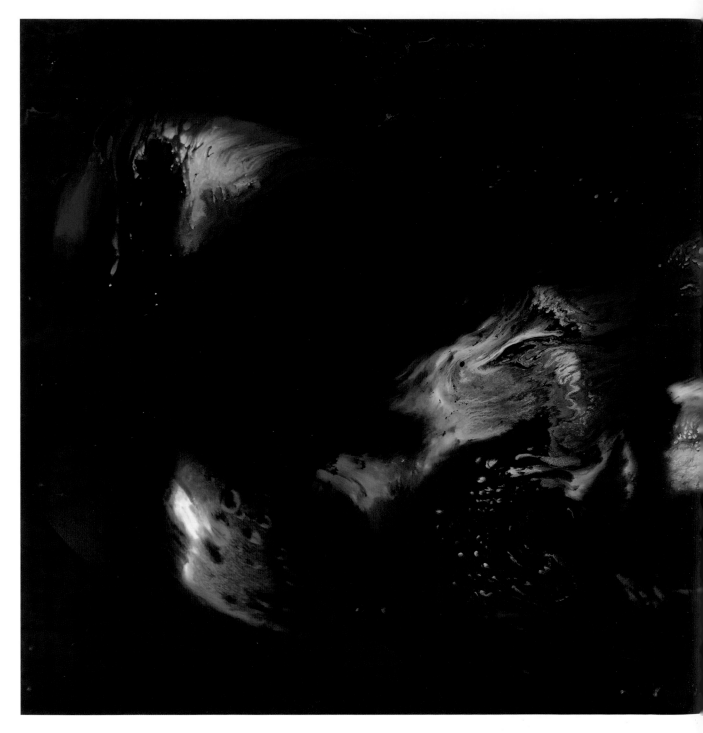

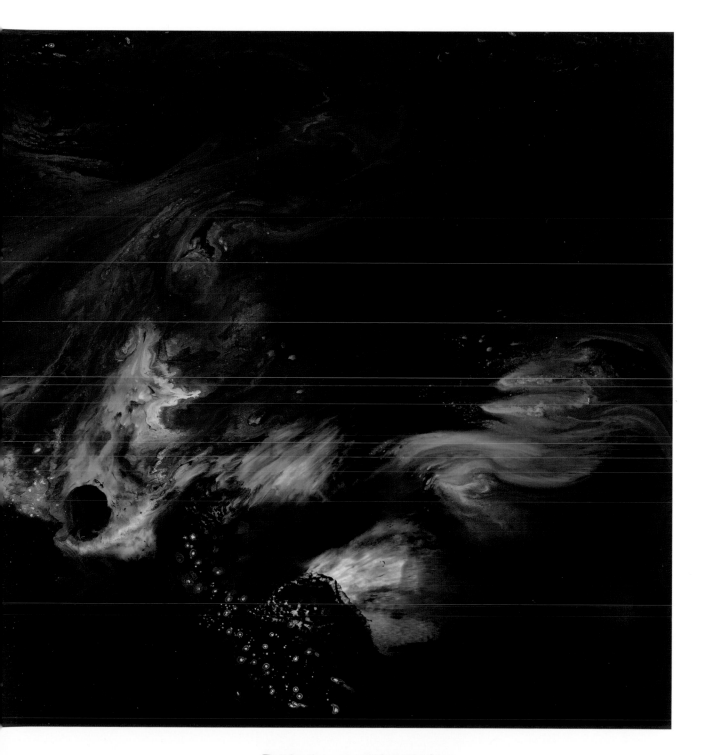

Celia Paul
St George's, Bloomsbury
Oil
151 × 164 cm

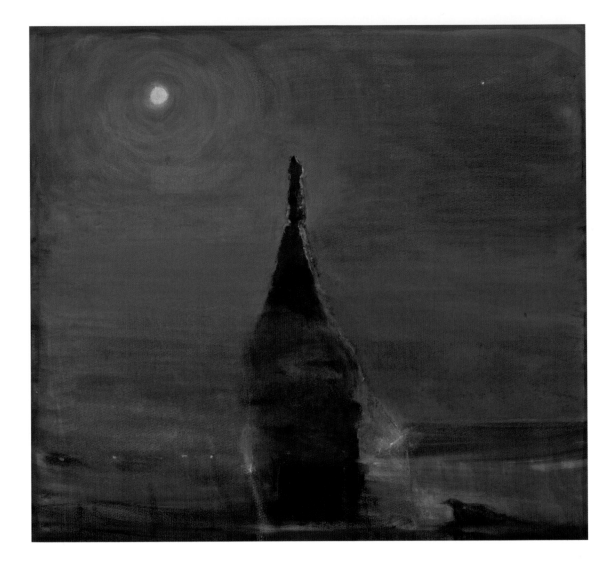

Mick Moon RA
Towpath
Acrylic
122 × 122 cm

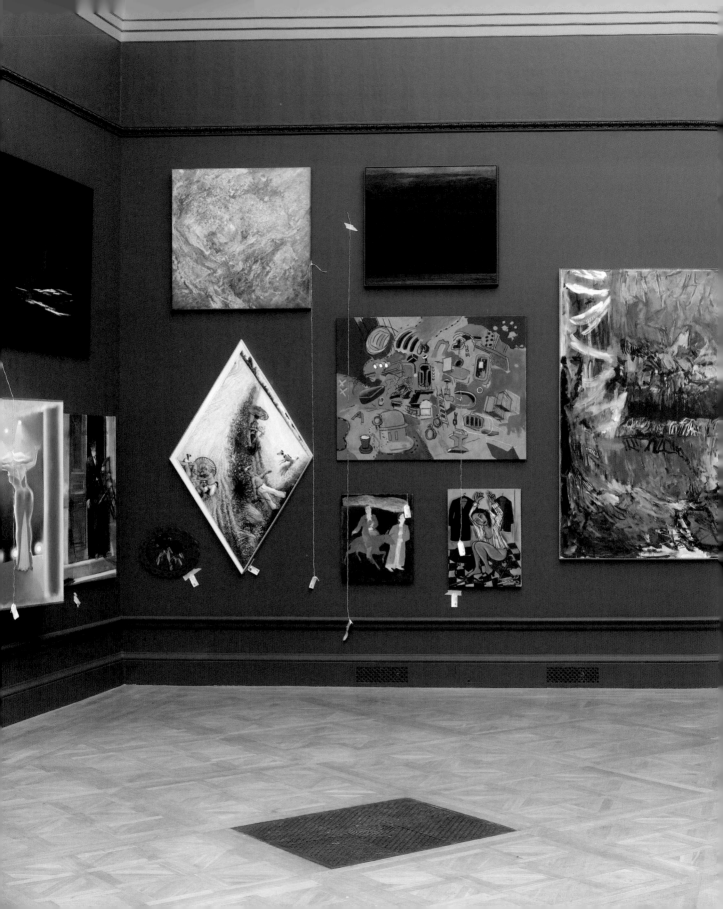

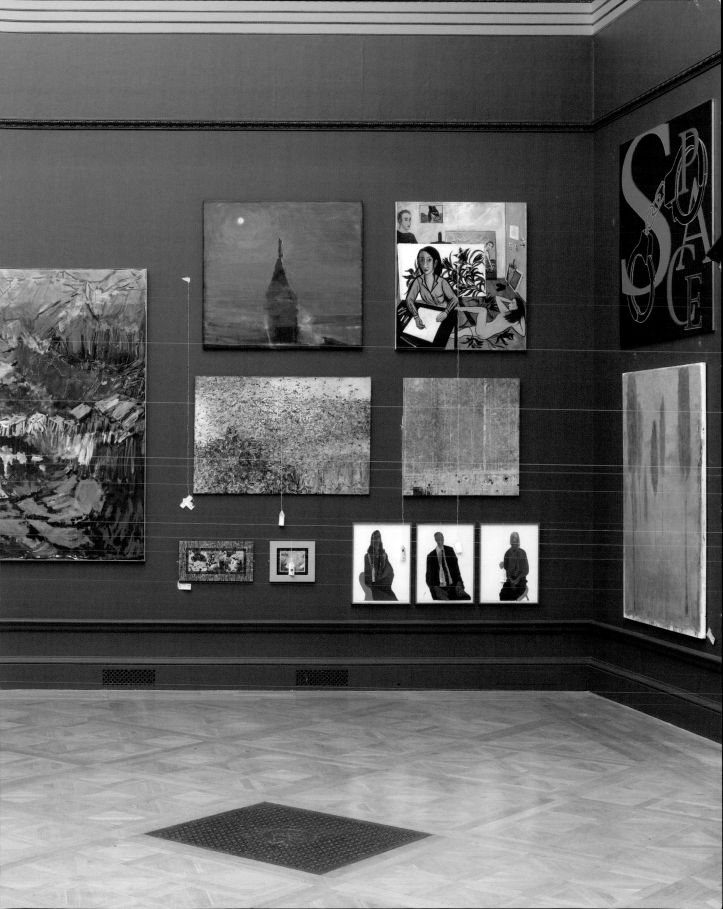

John Hubbard
Stone Group Corfu
Oil
147 × 147 cm

Per Kirkeby
Untitled
Tempera
300 × 350 cm

Adrian Berg RA
Low Tide, Beachy Head, 30 October
Oil
Triptych, 292 × 366 cm

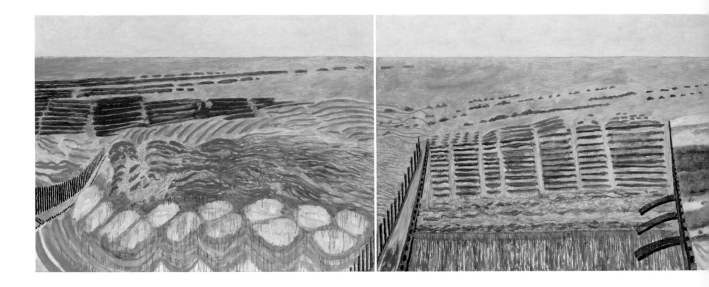

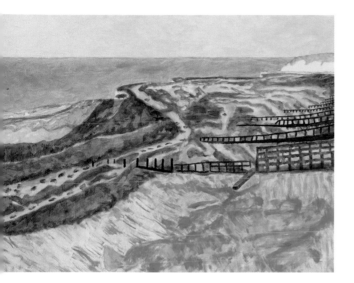

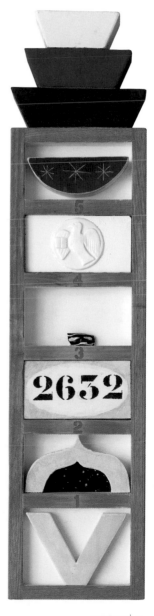

Anthony Whishaw RA
Slow Appearance I, Puente del Congosto
Acrylic
122 × 183 cm

Terry Setch RA
Time Is Running Out
Mixed media
232 × 238 cm

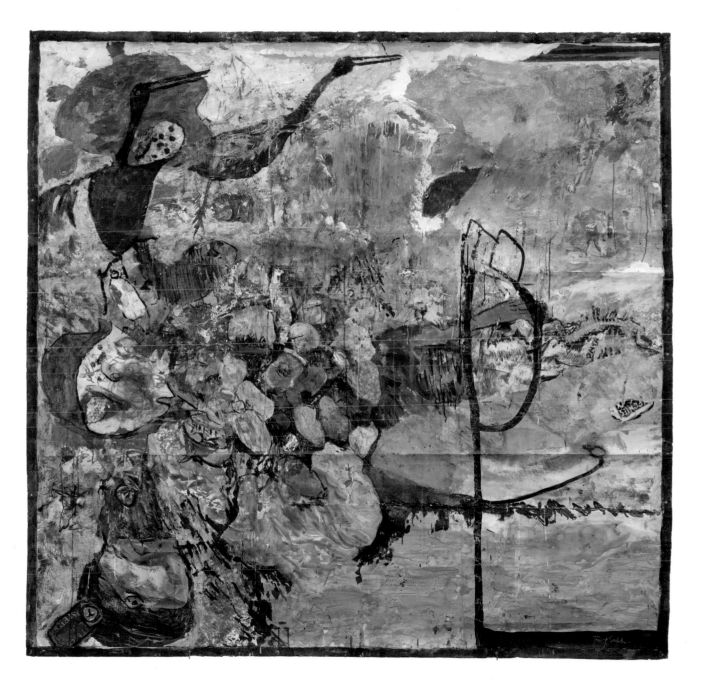

Tom Phillips CBE RA
The Remains of the Day II
Oil
24 × 30 cm

Prof Paul Huxley RA
Proteus X
Acrylic
173 × 173 cm

Mali Morris RA
Angelas
Acrylic
120 × 150 cm

Albert Irvin RA
Memory II
Acrylic
61 × 61 cm

Anthony Green RA
Summer Landscape, Autumn Lovers
Oil
244 × 152 cm

Olwyn Bowey RA
Coming in to Land
Oil
126 × 87 cm

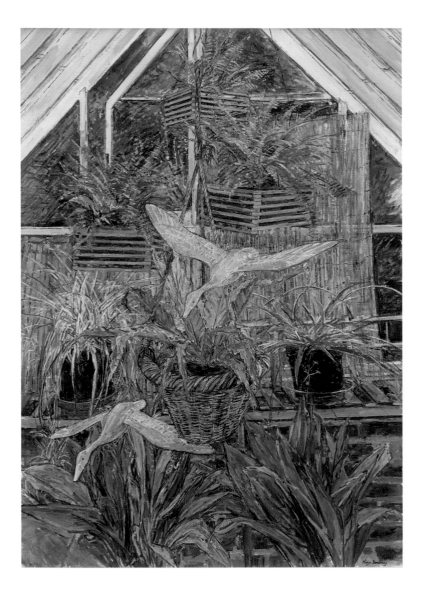

Ken Howard OBE RA
Dora, Venice Interior
Oil
101 × 120 cm

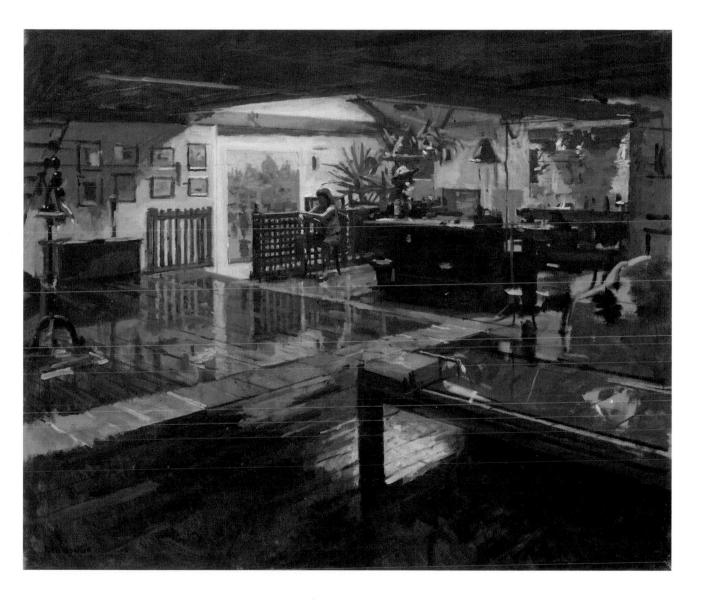

Hughie O'Donoghue RA
Cumae: Labyrinth
Oil
244 × 300 cm

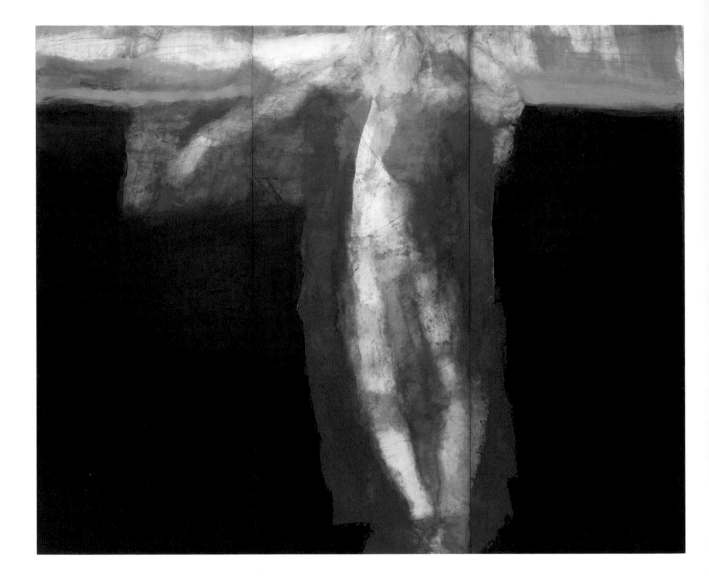

Dr Barbara Rae CBE RA
Yesnaby Fields
Mixed media
118 × 92 cm

Allen Jones RA
Razzle Dazzle
Oil paint on wood panels
181 × 167 cm

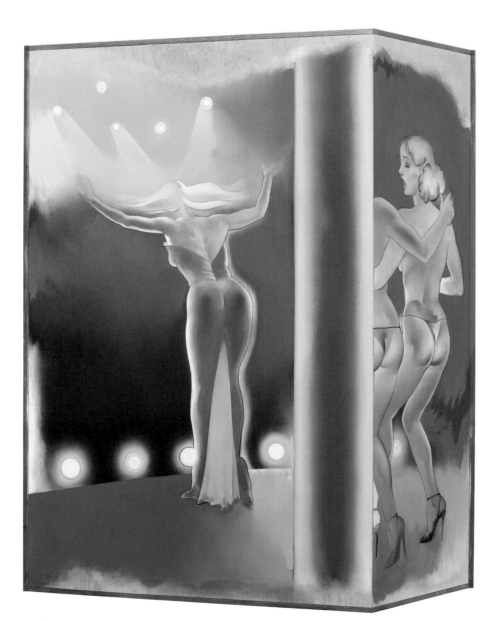

Eileen Cooper RA
Longing
Oil
153 × 137 cm

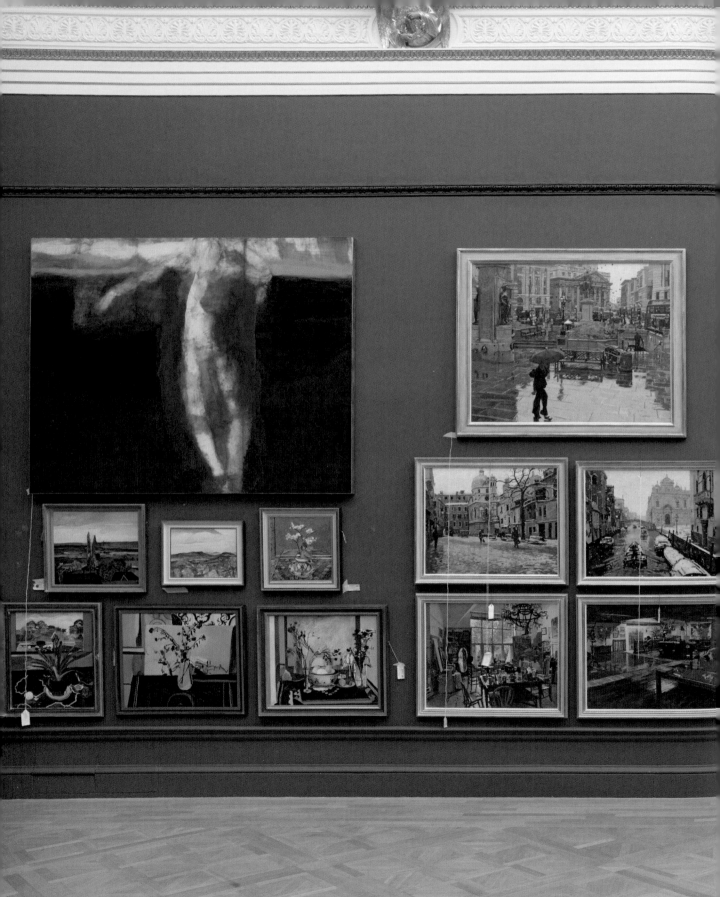

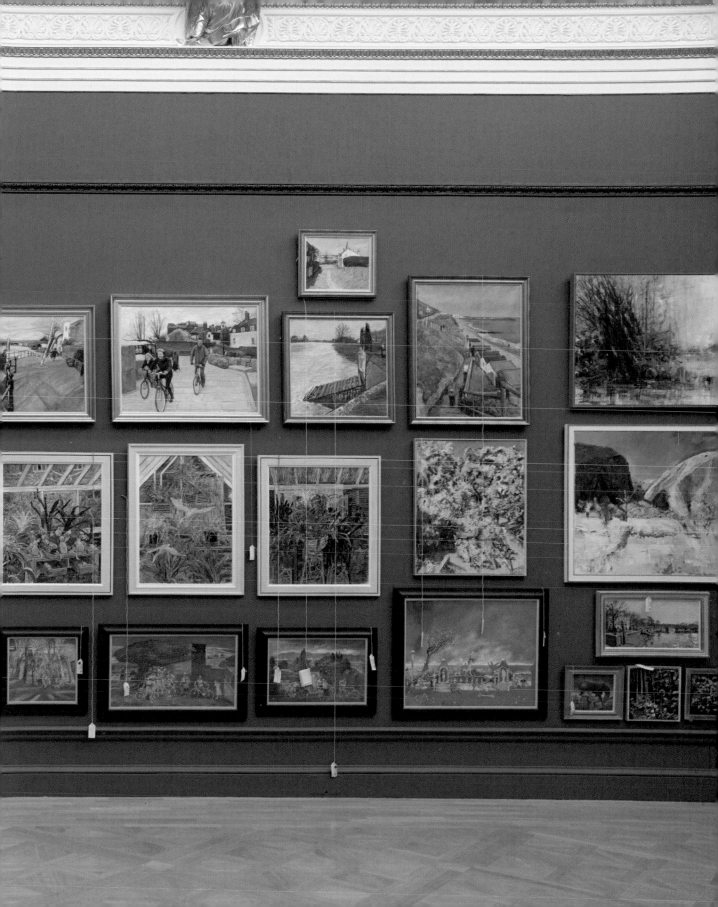

The late Ben Levene RA
Autumn from the Studio
Oil
70 × 79 cm

William Bowyer RA
River Thames
Oil
91 × 92 cm

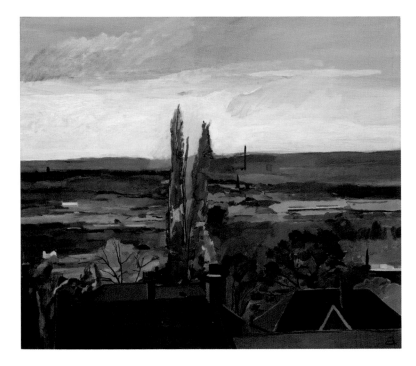

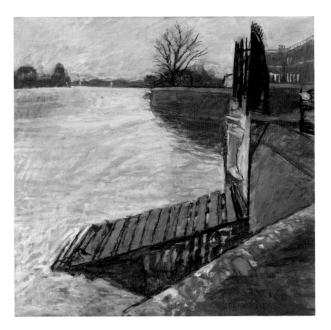

Michael Rooney RA
Boy Walking, Bird and Cat Following
Oil
60 × 60 cm

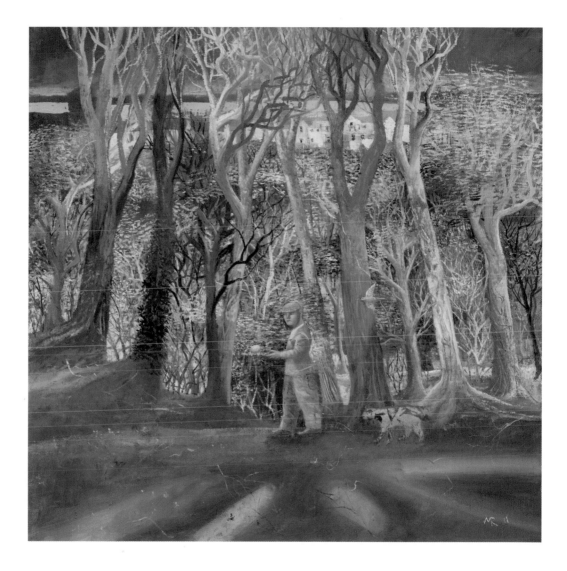

Jennifer Durrant RA
From a Series: Come Home by Weeping Cross
Acrylic
274 × 340 cm

Prof Maurice Cockrill RA
Dark Enigma
Acrylic
210 × 195 cm

Paul Winstanley
Landscape 34
Mixed media
44 × 39 cm

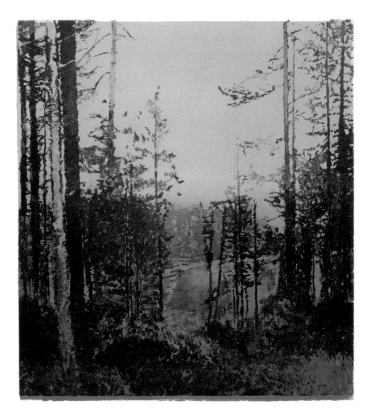

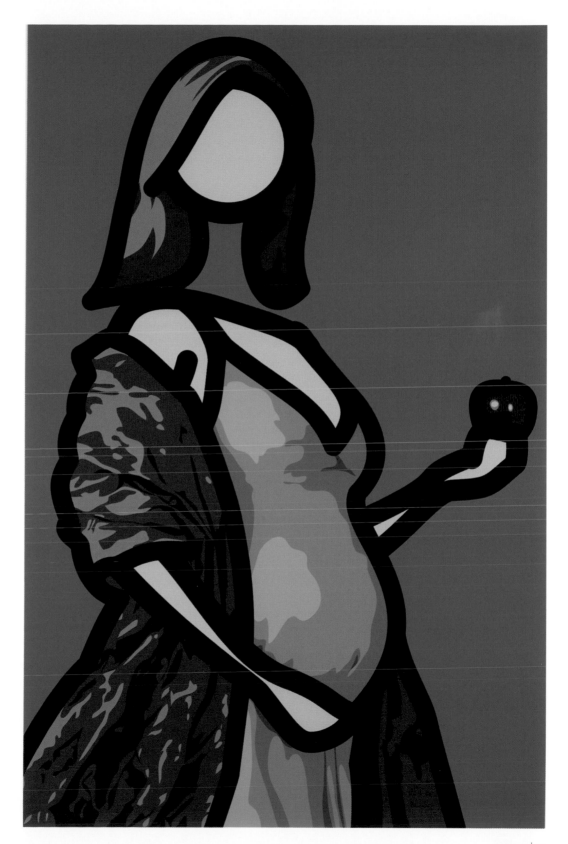

Dexter Dalwood
And the Days Are Not Full Enough and the Nights Are Not Full Enough
Screenprint
40 × 29 cm

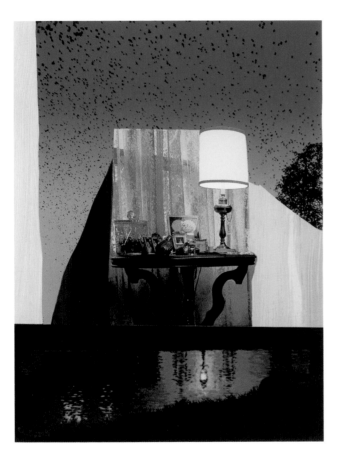

Stephen Chambers RA
A Country of Tall Firs
Screenprint
74 × 91 cm

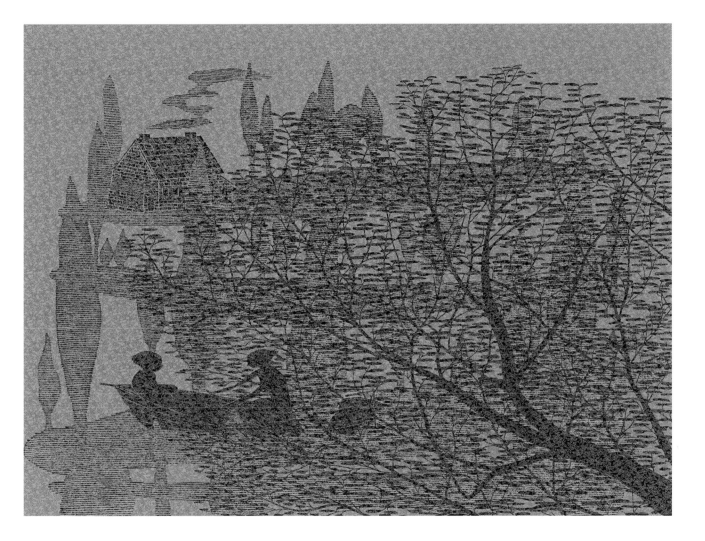

Jim Dine
Paintbrush (From the Tools)
Lithograph
60 × 45 cm

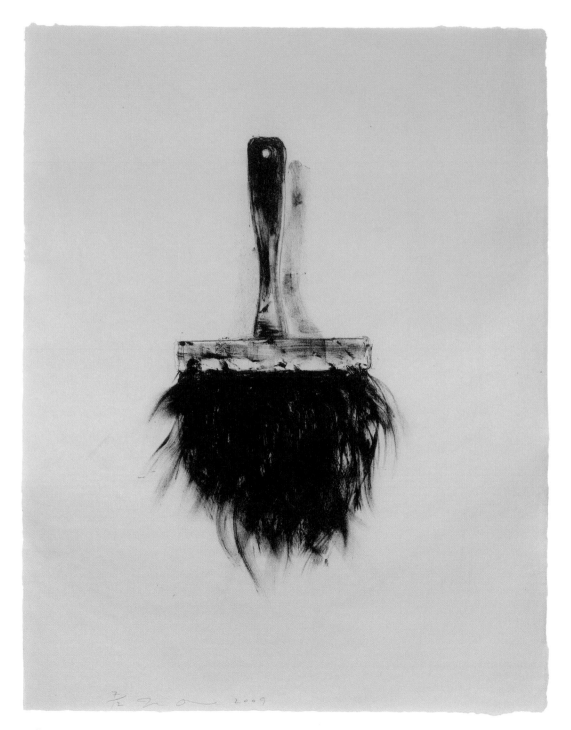

Paula Rego
Spider
Etching
49 × 36 cm

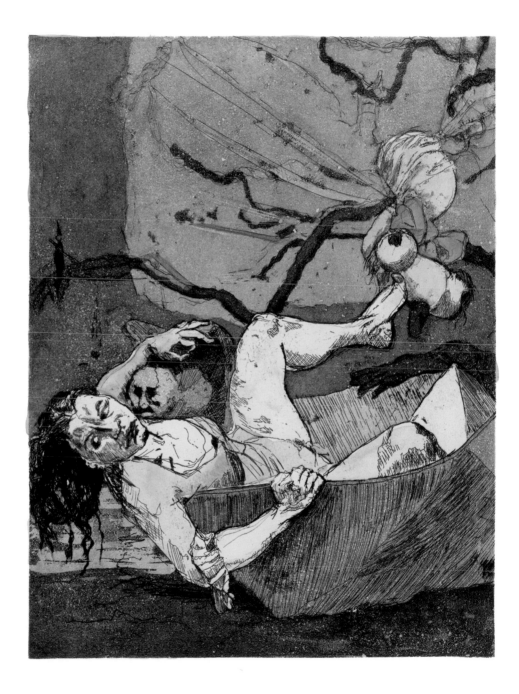

Peter Freeth RA
Shoptalk on Parnassus (Le Chat de M. Manet)
Aquatint
56 × 47 cm

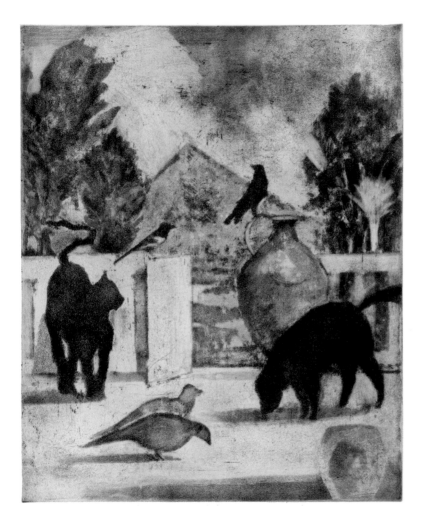

Prof Norman Ackroyd CBE RA
Shiant – Garbh Eilean
Etching
48 × 77 cm

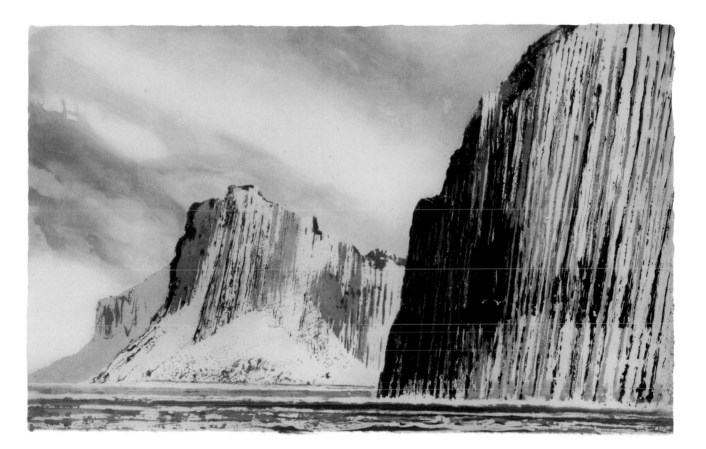

Katsutoshi Yuasa
The Pursuit of Happiness #2
Woodcut
122 × 91 cm

Frances Walker
Wordie Hut
Lithograph and screenprint
33 × 77 cm

Elizabeth Magill
Parlous Land
Lithograph
60 × 85 cm

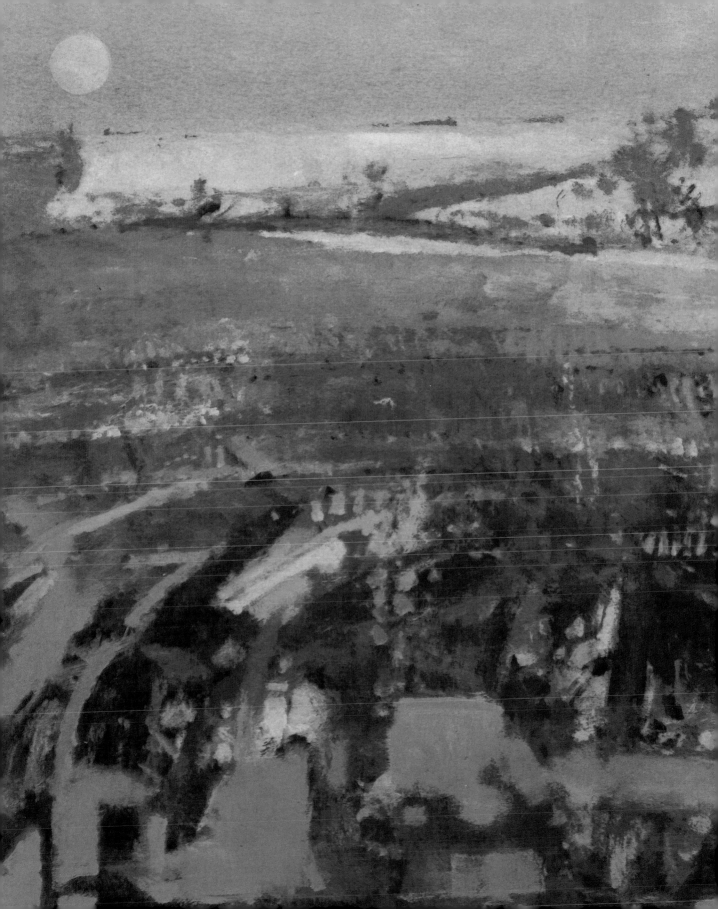

Dr Jennifer Dickson RA
Stone Garden: Three Roses for Marie–Antoinette
Mixed media
24 × 36 cm

Tracey Emin RA
Me too – Glad to hear I'm a Happy Girl
Monoprint
57 × 81 cm

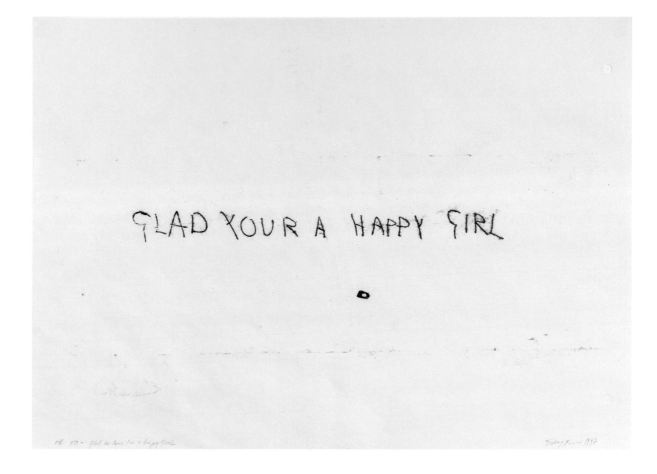

Gillian Ayres OBE RA
Star Spangled
Mixed media
77 × 104 cm

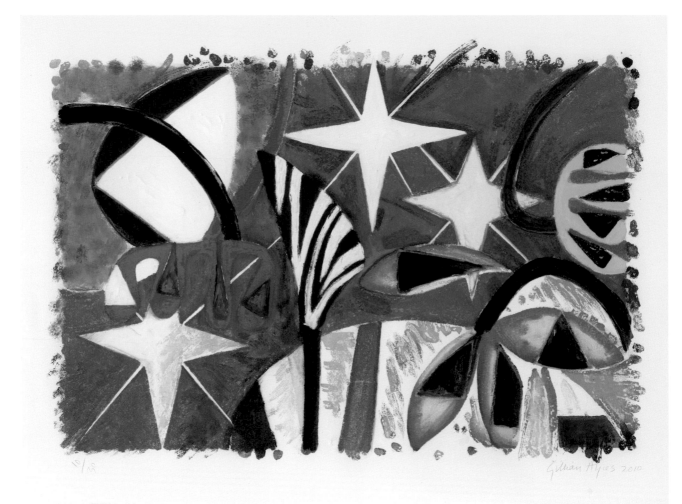

Bill Jacklin RA
Crossing the Square in the Snow
Etching
49 × 39 cm

Frederick Cuming RA
Thaw
Screenprint
28 × 37 cm

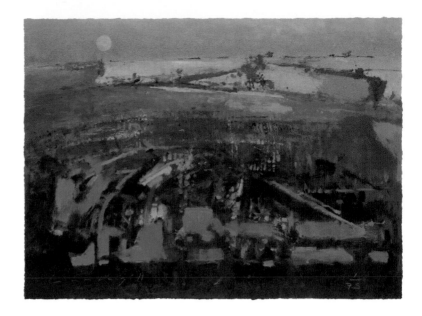

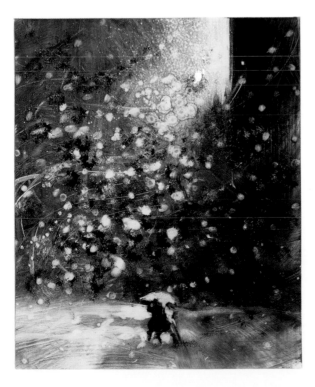

Andrew Curtis
Gold Nibs
Screenprint
55 × 55 cm

John Duffin
Arrival (King's Cross St Pancras Station)
Etching
41 × 28 cm

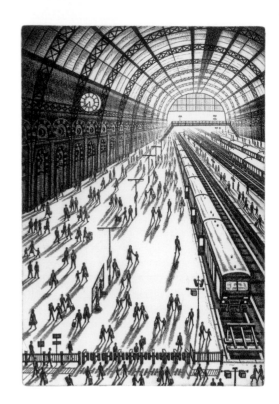

Jane Lydbury
Venus and Adonis
Woodcut
13 × 15 cm

Paul Caton
Do Not Remember Me
Pencil
56 × 65 cm

Prof Chris Orr MBE RA
'Who done it?'
Lithograph and silkscreen
69 × 92 cm

Glen Baxter
For two years I worked for the Archbishop collating and
updating his archive of pornography and railway memorabilia
Digital print
68 × 49 cm

Gavin Nolan
Tesseract
Etching
22 × 15 cm

Rose Bradford
Why Can't You Be Reasonable?
Etching
50 × 50 cm

Lorraine Tomlinson
Piranha
Photographic print
16 × 21 cm

Dame Elizabeth Blackadder DBE RA
Crabs and Prawns
Watercolour
31 × 37 cm

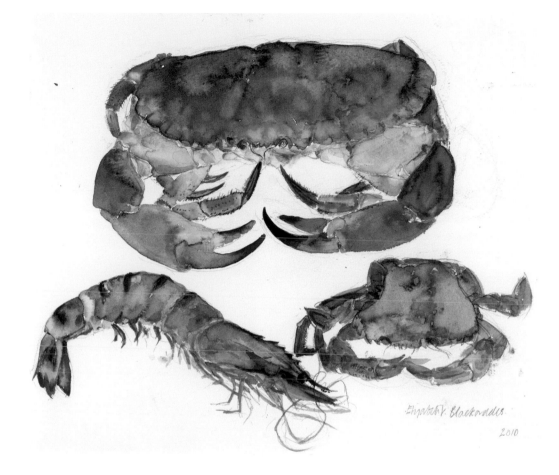

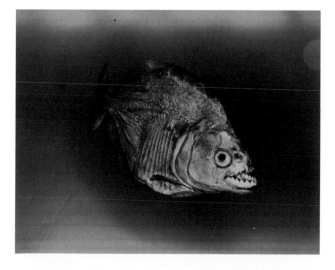

Gillian Golding
Morandi's Dog
Etching
21 × 23 cm

Bill Jacklin RA
Portuguese Water Dog
Etching
29 × 26 cm

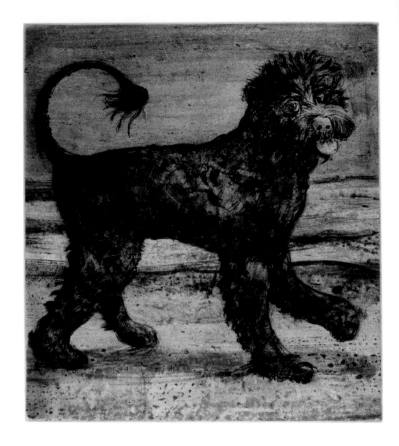

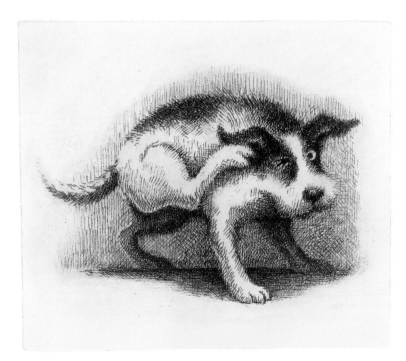

Jane Eva Cooper
Frog on Frond
Etching
12 × 14 cm

Julia Bristow
Ivy Growing Up Flint Wall
Linocut
17 × 11 cm

LARGE
WESTON
ROOM

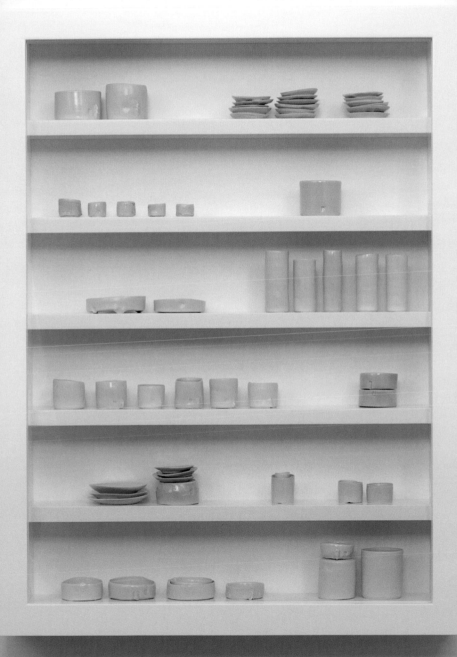

Prof Stephen Farthing RA
Gaddafi's Tent
Oil
173 × 205 cm

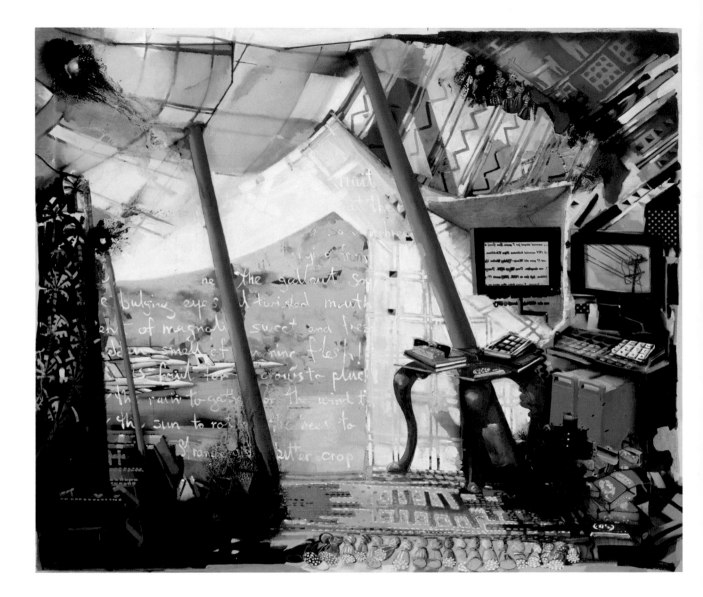

Vicken Parsons
Untitled (1018)
Oil
21 × 25 cm

Bernd Koberling
September und Schweigen, Oktober
Watercolour
66 × 103 cm

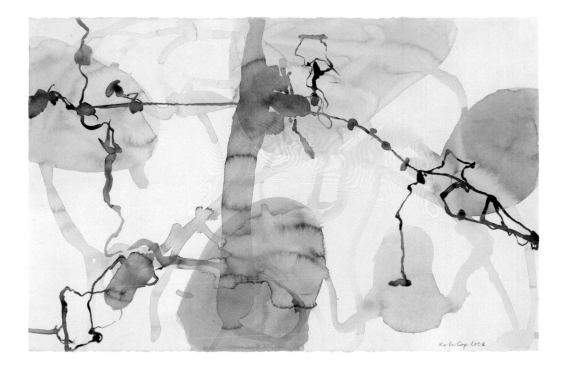

Mimmo Paladino Hon RA
Fuga in Egitto
Mixed media
235 × 326 cm

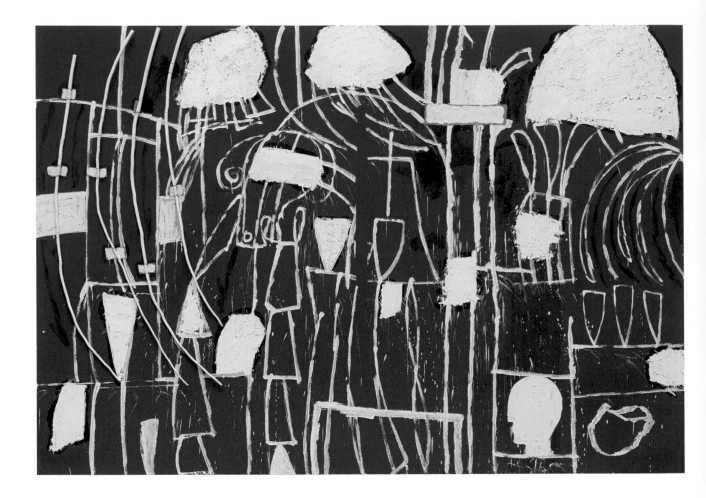

Tony Bevan RA
Self-portrait after Messerschmidt
Mixed media
83 × 116 cm

Frank Auerbach
Jake
Etching
41 × 29 cm

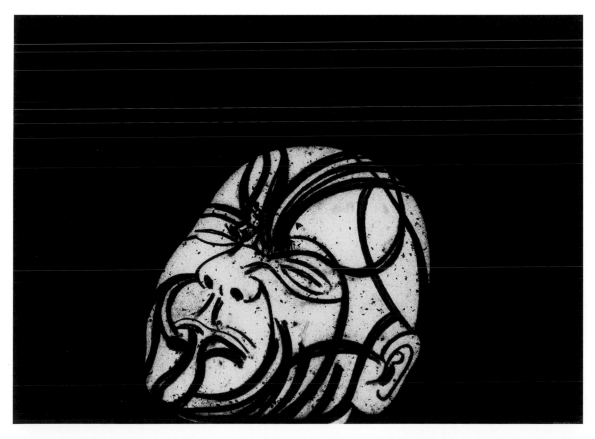

James Hugonin
Binary Rhythm (I)
Oil and wax on wood
189 × 169 cm

Georg Baselitz Hon RA
Monogramm
Oil
300 × 250 cm

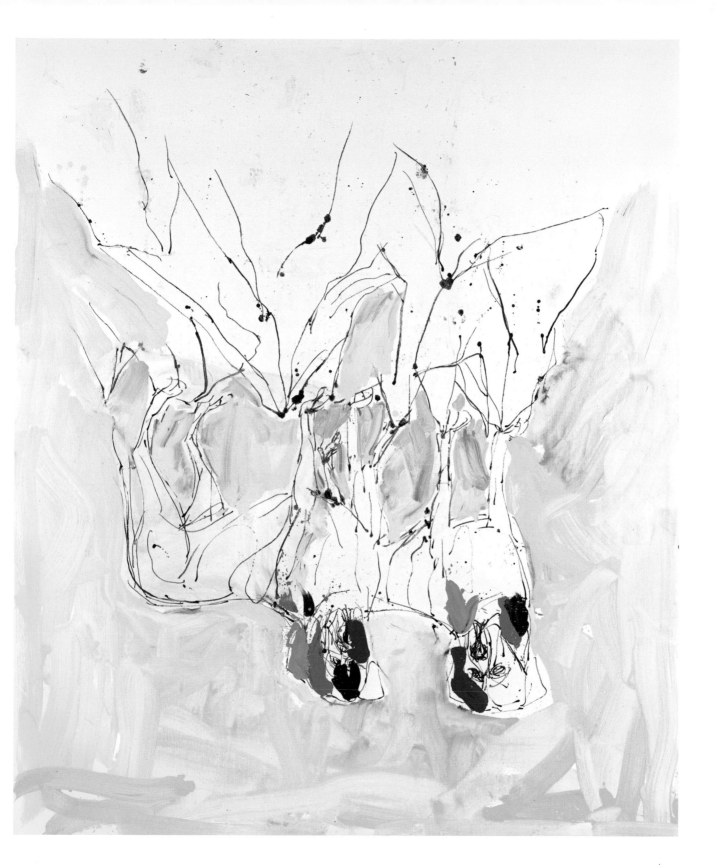

Anselm Kiefer Hon RA
Aurora
Mixed media
260 × 380 cm

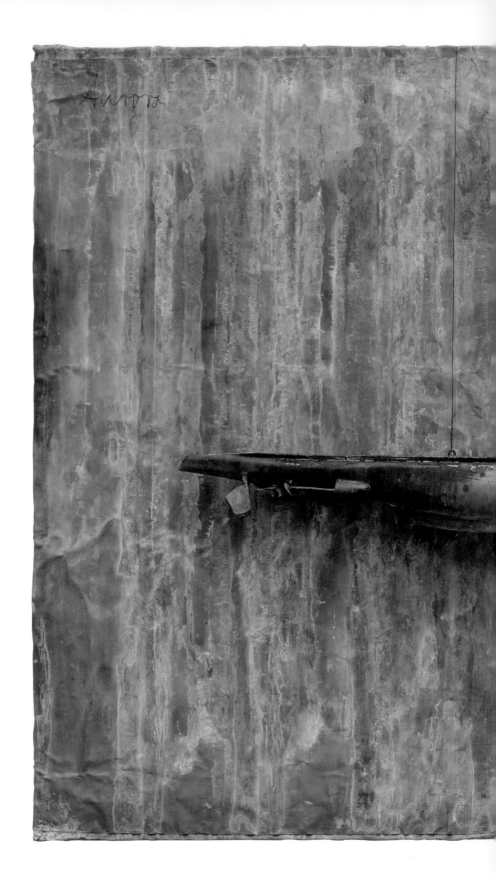

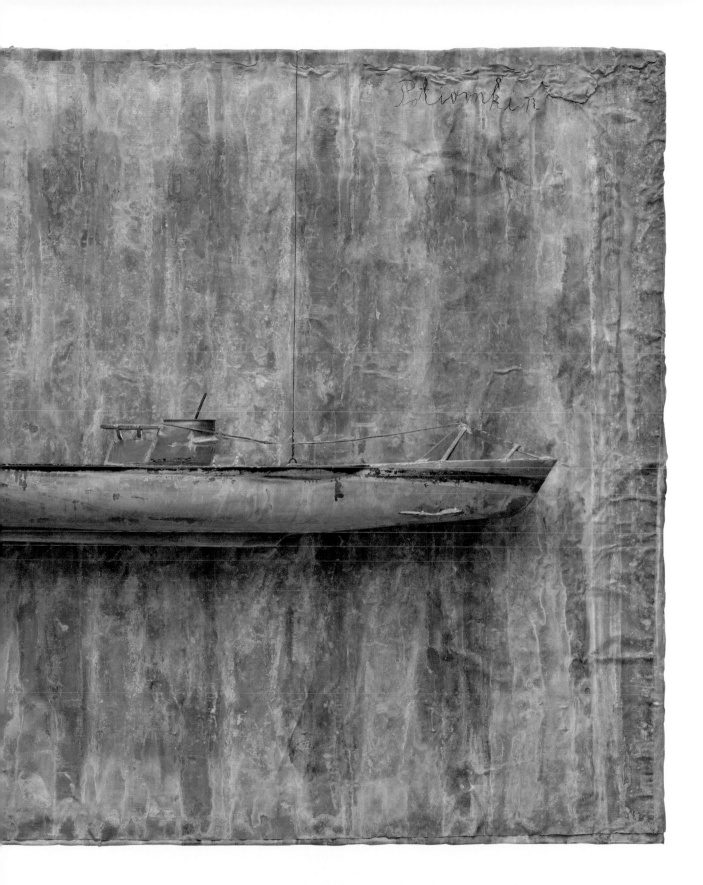

SMALL
WESTON
ROOM

Cedric Huson
Eleven Miles Later
Acrylic
33 × 75 cm

June Berry
Afternoon in the Park
Oil
42 × 54 cm

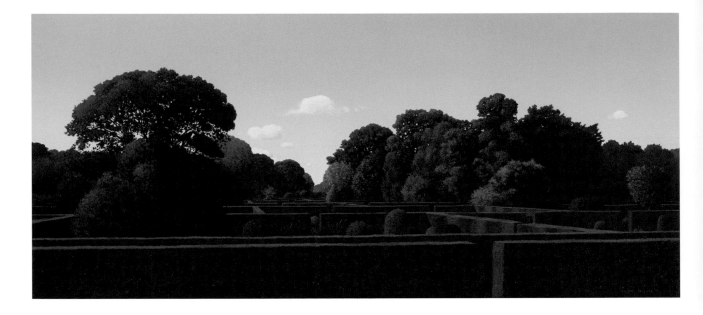

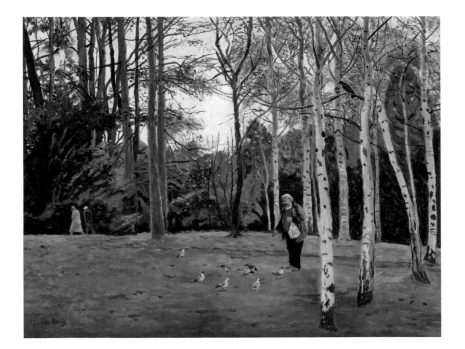

Maurice Sheppard
The Voice of a Tree and Its Echo Caught in Time
Oil
29 × 37 cm

Ann Johnson
Little Owl
Acrylic on paper
28 × 24 cm

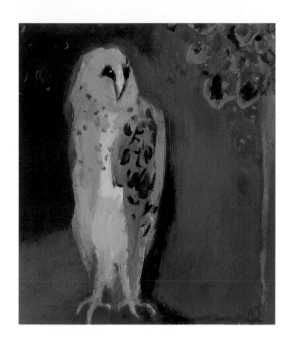

Brenda Evans
On the Crest of a Wave
Oil
39 × 29 cm

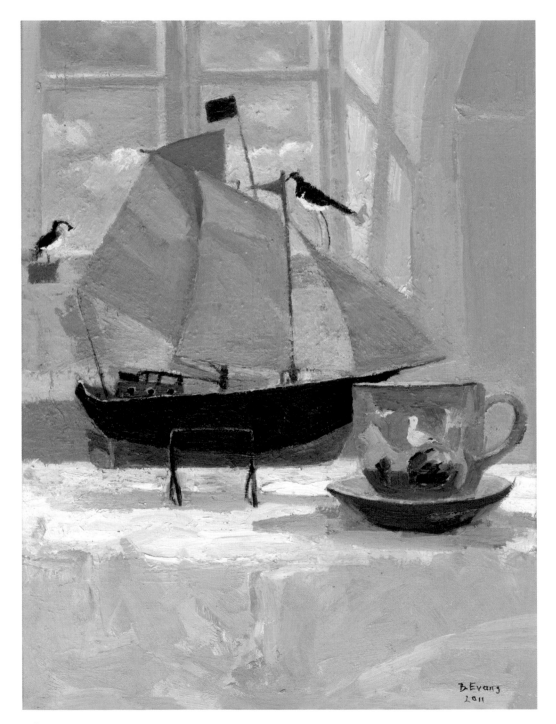

Ffiona Lewis
Geranium Lake – Anemone
Oil
35 × 47 cm

Diana Armfield RA
Sheep in the Rocky Stream, North Wales
Oil
27 × 27 cm

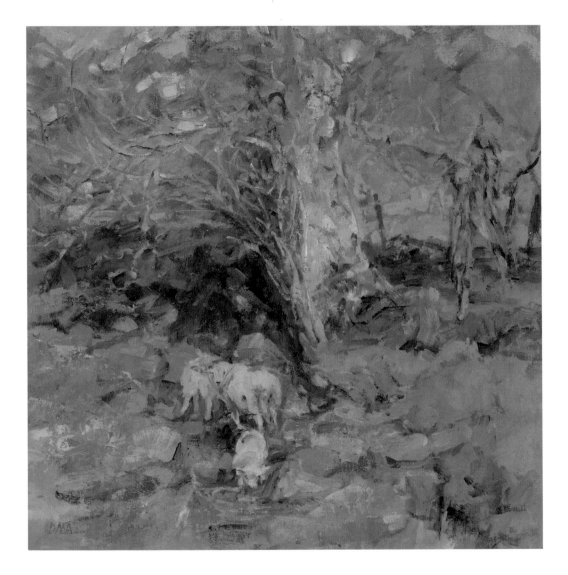

Jane Dowling
Jug II
Pencil and watercolour
20 × 20 cm

Bernard Dunstan RA
Morning Drawing (2)
Chalk
21 × 23 cm

IV

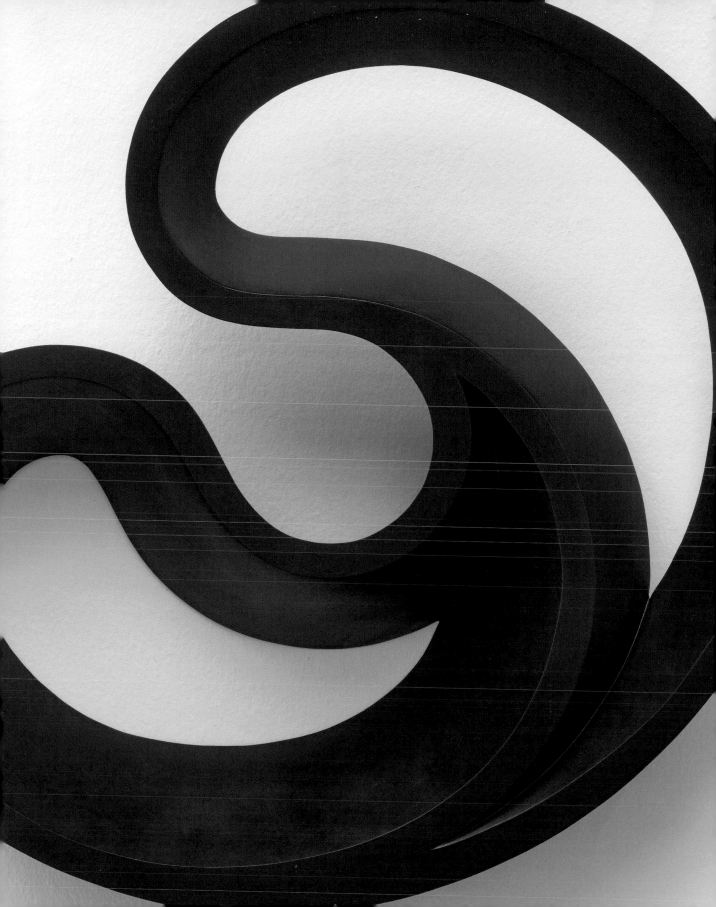

Ann Christopher RA
The Dark Is Equal to the Light
Bronze
H 75 cm

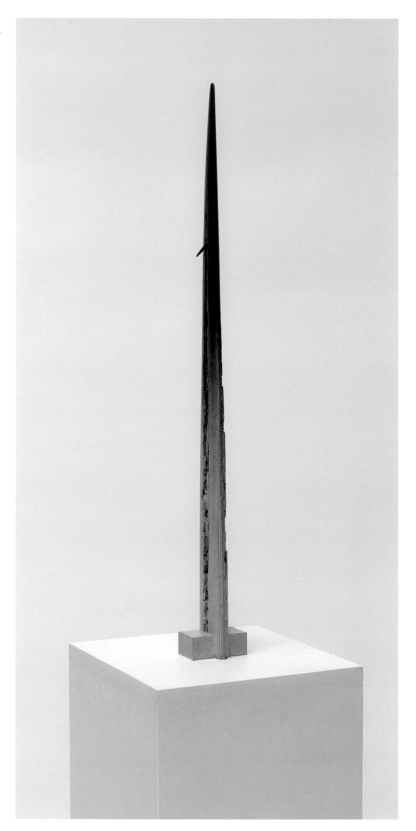

John Carter RA
Four Identical Shapes
Mixed media
H 100 cm

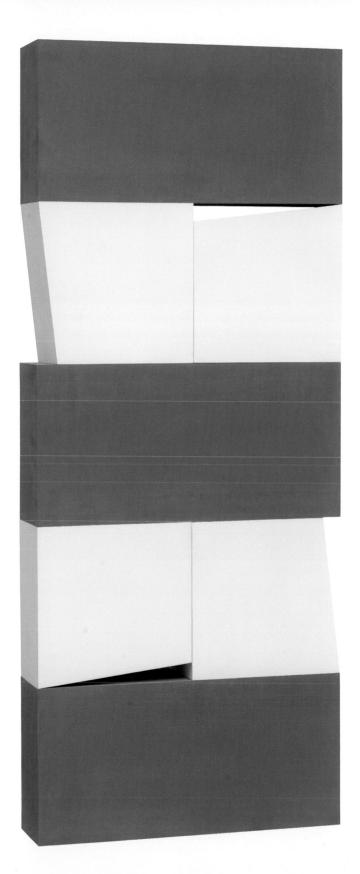

Boyd and Evans
Clean Hill Summer
Archival inkjet print
90 × 143 cm

Stephanie Carlton Smith
Tree
Mixed media
H 47 cm

John Bremner
Route
3D Z–Corp print
H 20 cm

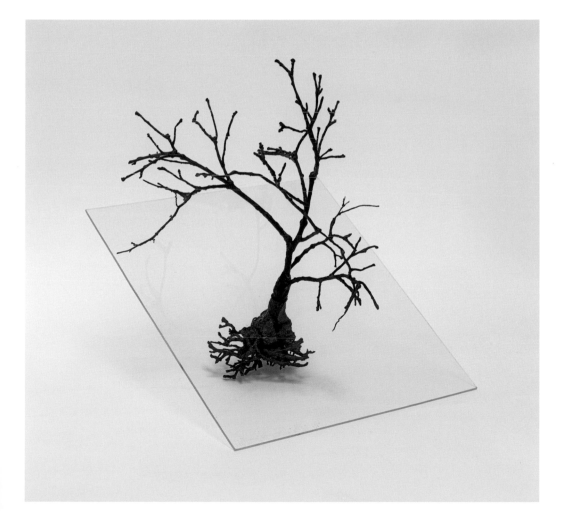

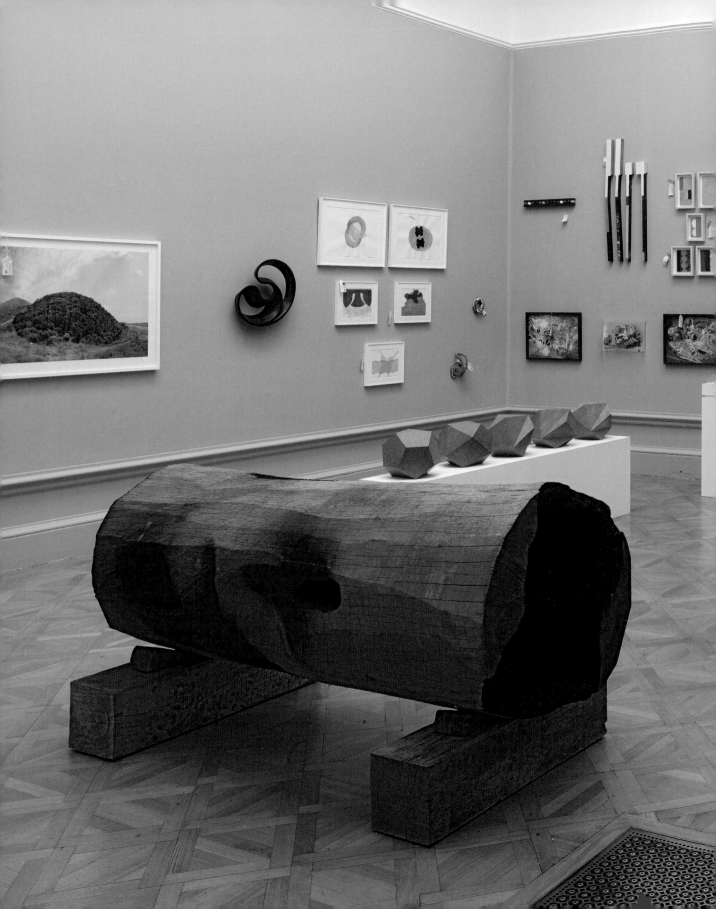

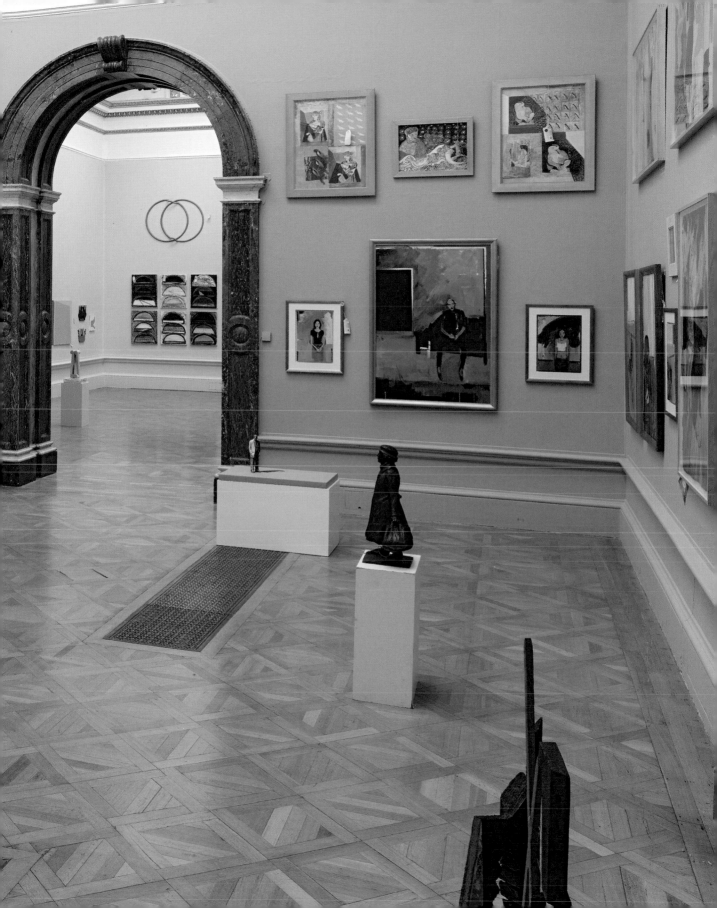

Alison Wilding RA
Swallow
Mixed media
29 × 30 cm

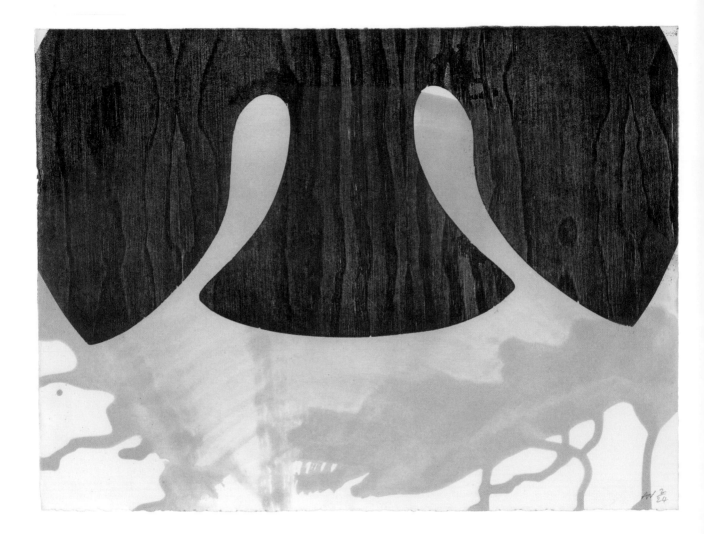

Nigel Hall RA
Chinese Whisper
Cast bronze
H 66 cm

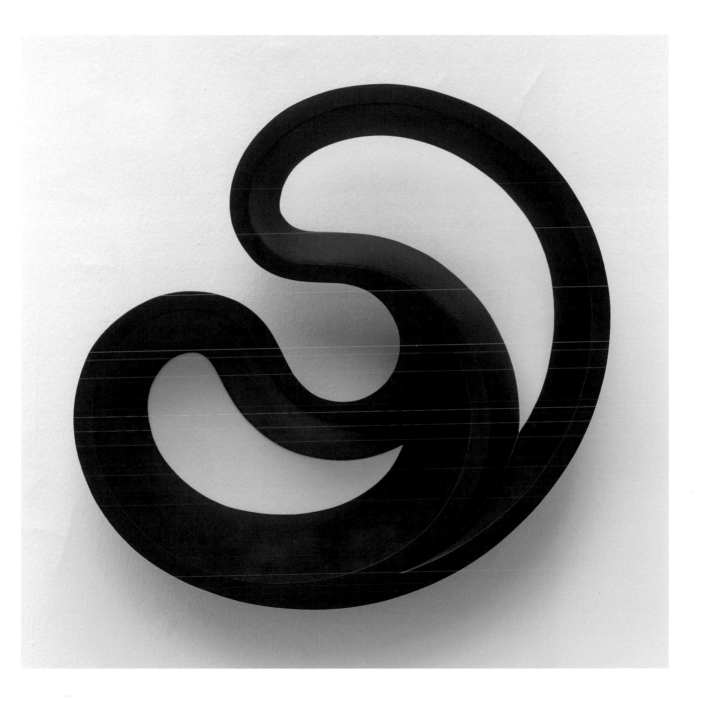

David Remfry MBE RA
Late Night Dancing
Watercolour
152 × 101 cm

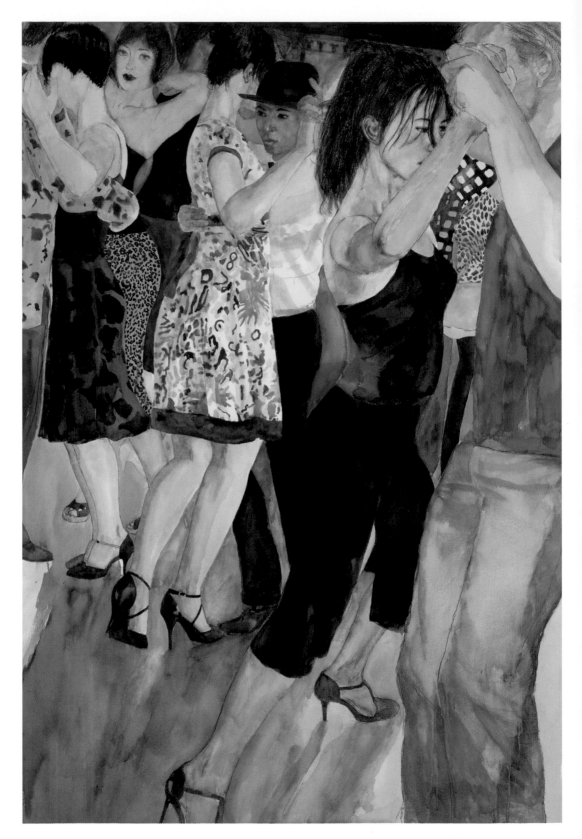

Gus Cummins RA
Happy Days (sketch model)
Mixed media
36 × 60 cm

Kenneth Draper RA
Light through Dark
Mixed media
40 × 40 cm

Sonia Lawson RA
Fais de Beaux Rêves
Oil
90 × 72 cm

John Wragg RA
He Once Danced
Acrylic
150 × 104 cm

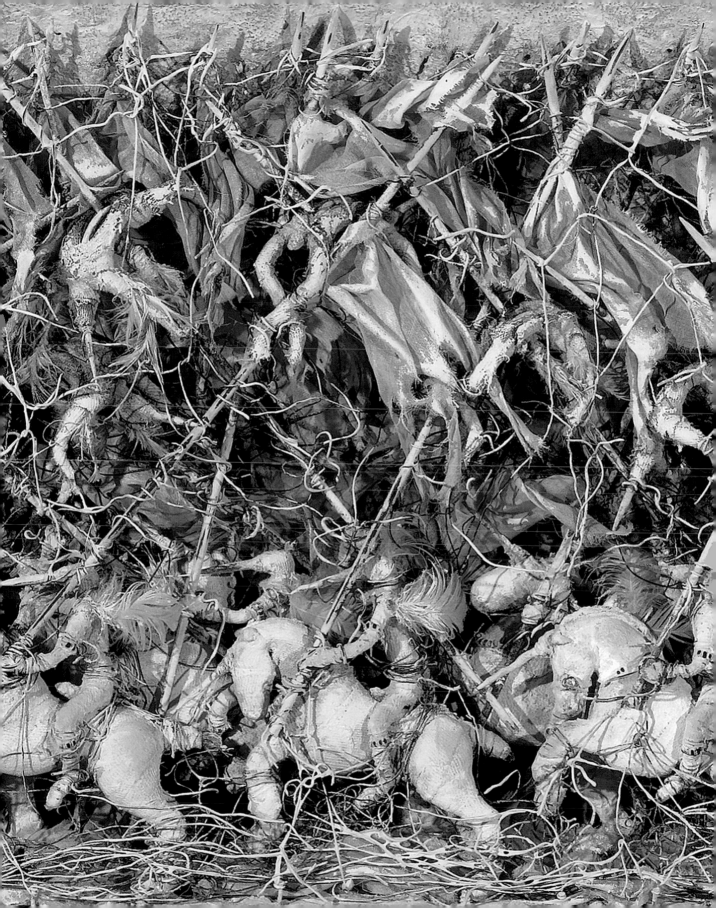

Basil Beattie RA
Drawing in the Night (Janus Series)
Oil on wax
77 × 61 cm

Tess Jaray RA
Dream of a Wall (Blue and White)
Mixed media
94 × 94 cm

Cathy de Monchaux
Sweetly the Air Flew Overhead, Battle with Unicorns no. 9
Mixed media
31 × 114 cm

Prof Ian McKeever RA
Triptych
Gouache
74 × 101 cm

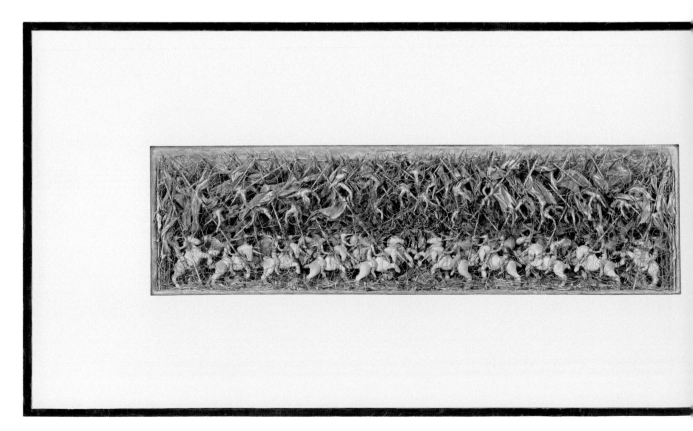

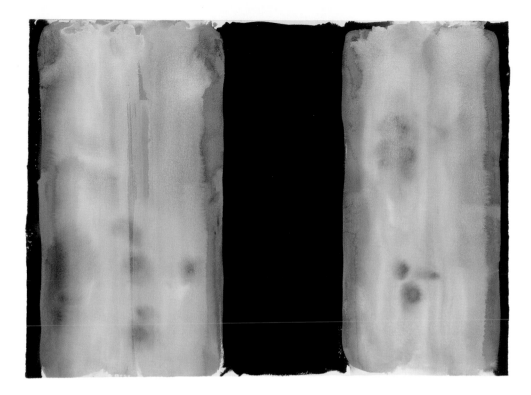

Laurence Haskell
Pool
Archival print
23 × 45 cm

Wendy Smith
Good Vibration
Gouache
67 × 60 cm

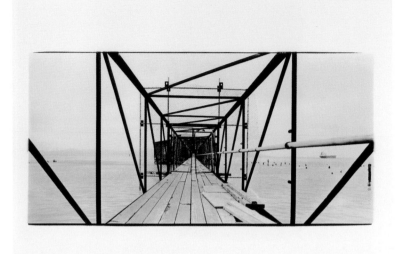

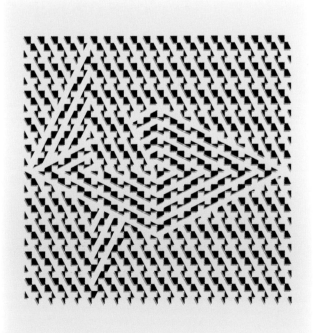

Trevor Sutton
Gathering Light (For Gwyther)
Oil on paper and board
124 × 94 cm

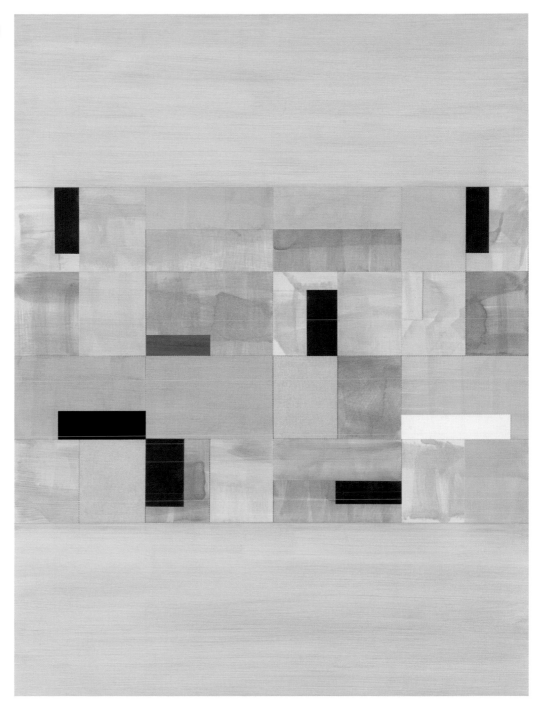

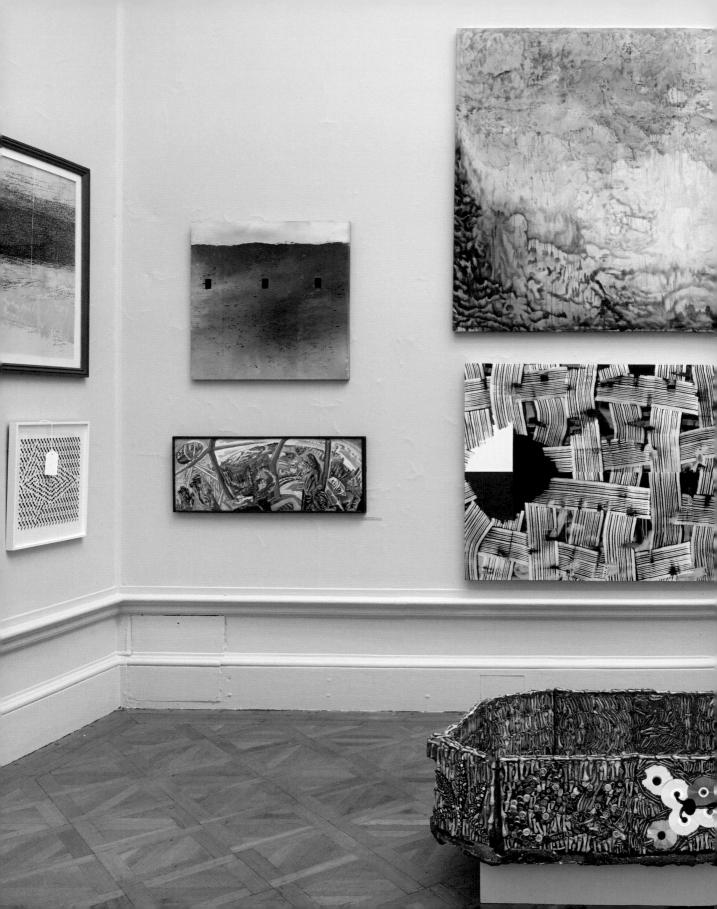

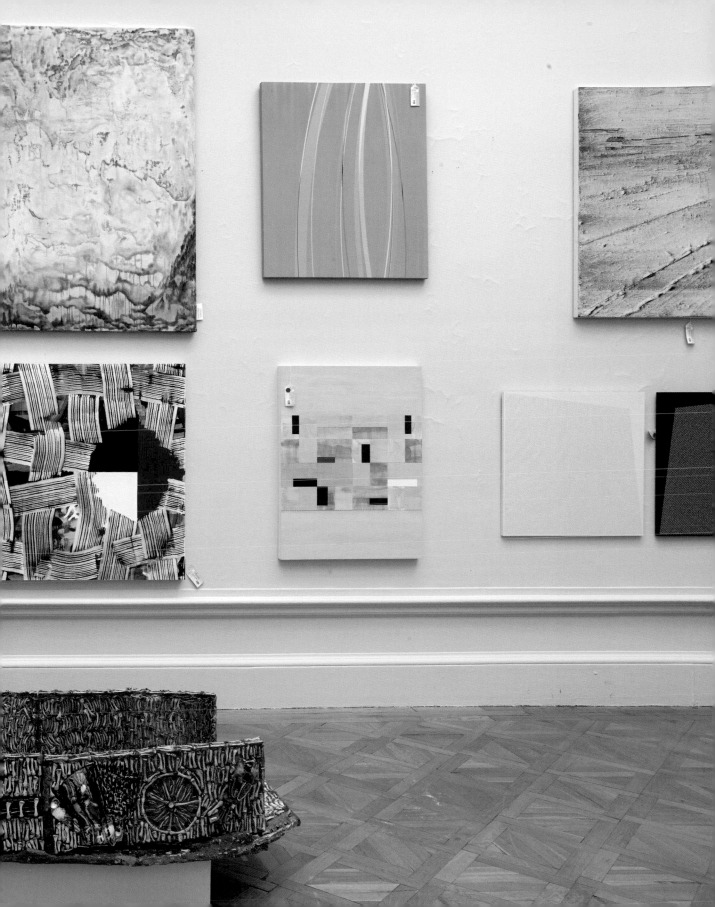

Timothy Hyman
Drawing on the Eye
Oil
46 × 121 cm

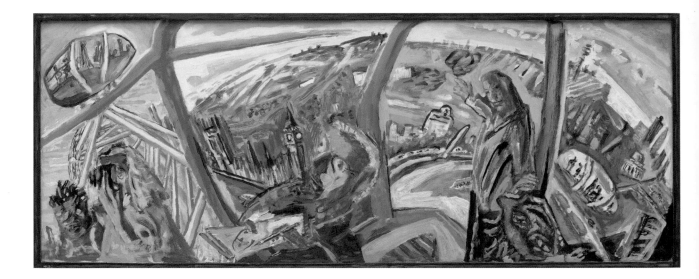

Neal Jones
Russian Satellite
Oil
35 × 47 cm

Jane Bustin
Holzlied
Mixed media
18 × 57 cm

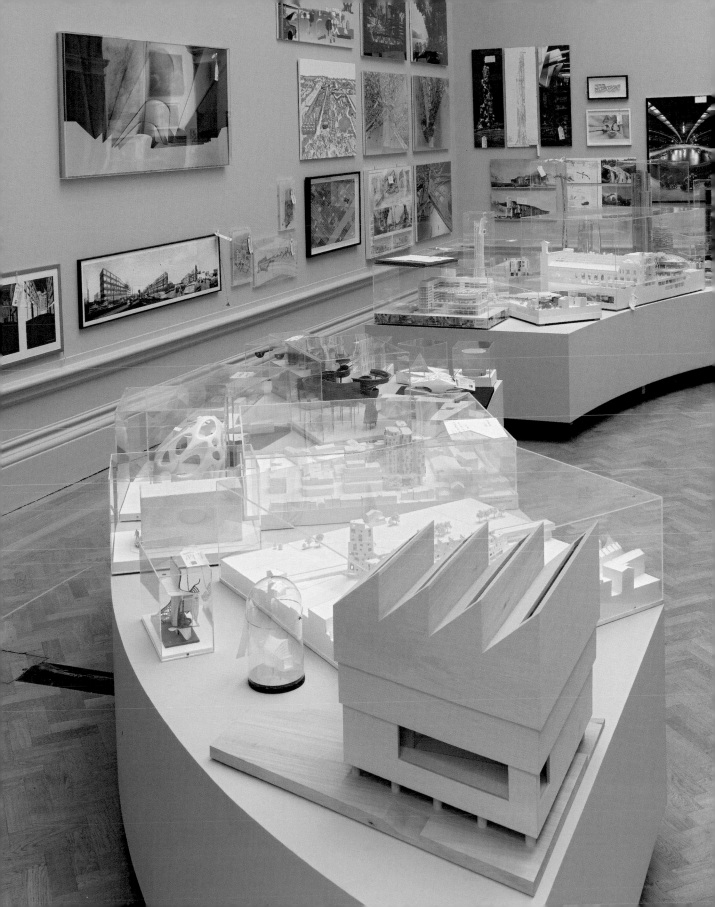

Eva Jiricna CBE RA
University and Cultural Centre, Zlín, Czech Republic (detail)
Duratrans on lightbox
83 × 53 cm

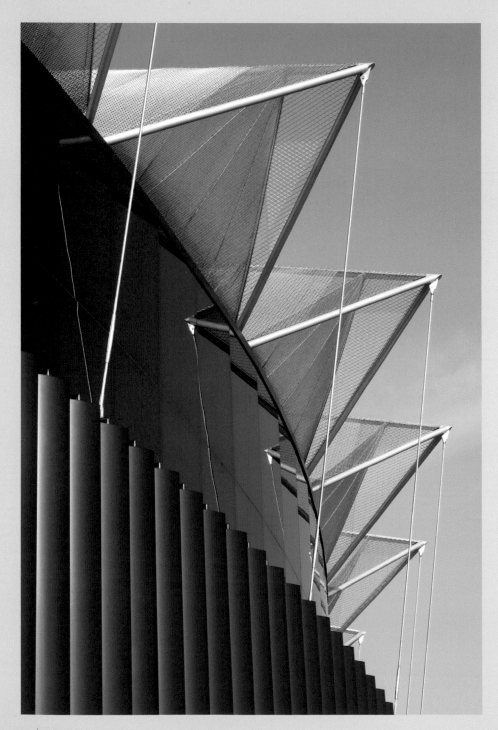

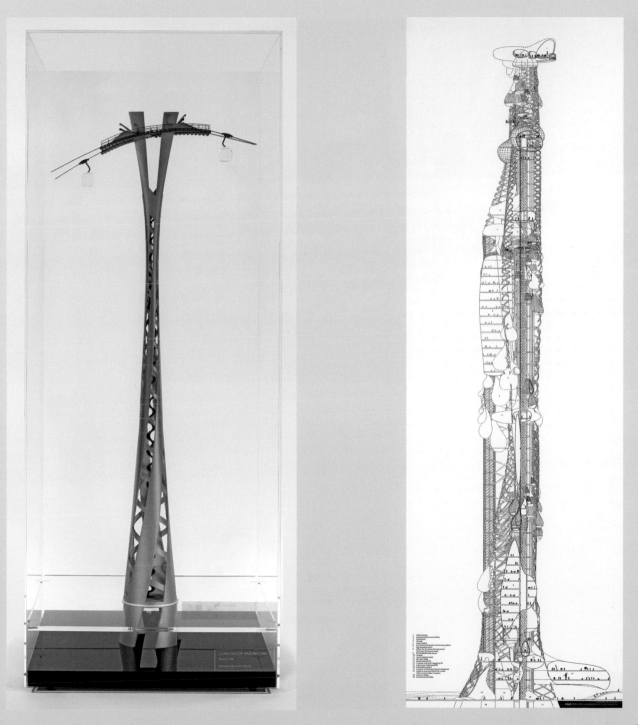

Chris Wilkinson OBE RA
London Cable Car South Main Tower
Mixed–media model
H 86 cm

Prof Sir Peter Cook RA
Taiwan Tower Taichung Section
Digital print
120 × 38 cm

Lord Foster of Thames Bank OM RA
West Kowloon Cultural District, Masterplan Sectional Perspective
Digital print
84 × 120 cm

Sir Nicholas Grimshaw CBE PRA
Crossrail: Architectural, Sectional Model
Model
H 68 cm

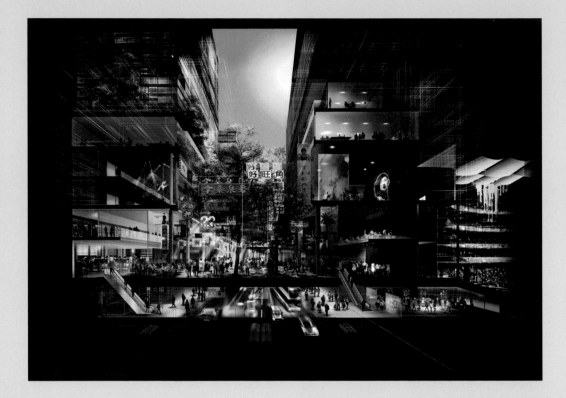

Prof William Alsop OBE RA
Bars and Restaurants – Gao Yang, Shanghai
Digital print
35 × 48 cm

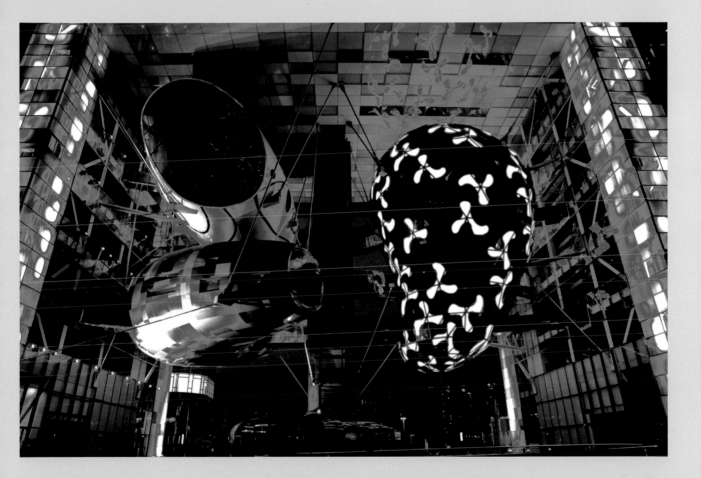

Lord Rogers of Riverside CH RA
Office Tower
Model
H 40 cm

Stanton Williams
From left to right:
Bourne Hill Offices, Wiltshire County Council
Hackney Marshes Centre, London Borough of Hackney
Sainsbury Laboratory, University of Cambridge
Giclée prints
Triptych, 93 × 174 cm

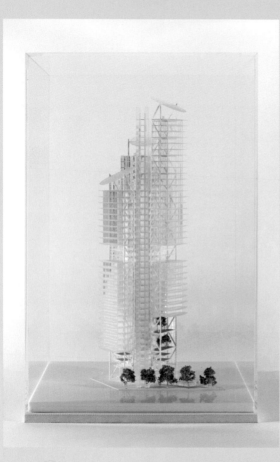

Zaha Hadid CBE RA
Concept Painting, Glasgow Riverside
Mixed media
90 × 200 cm

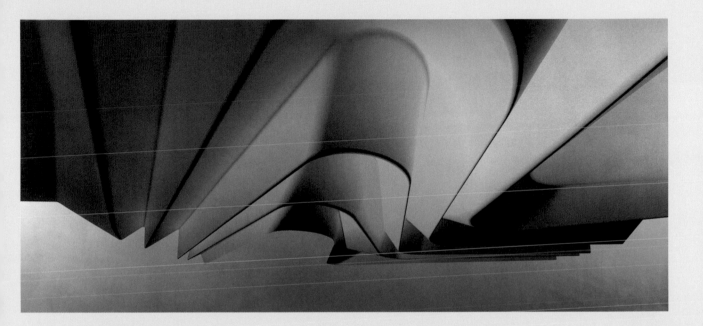

Michael Manser CBE RA
A Yachtsman's House on the Isle of Wight
Print
70 × 100 cm

Sir Richard MacCormac CBE RA
Kendrew Quadrangle, St John's College
Photograph
84 × 119 cm

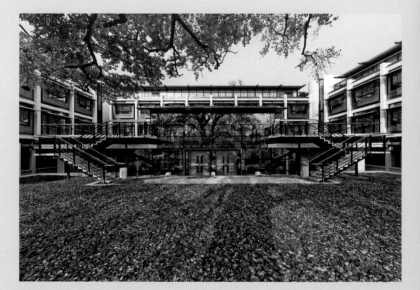

Spencer de Grey CBE RA
Masterplan for Slussen, Stockholm
Digital print of ink drawing
84 × 120 cm

Prof Ian Ritchie CBE RA
Sainsbury–Wellcome Centre
Etching
19 × 24 cm

Paul Koralek CBE RA
Plan Sketch
Ink
20 × 28 cm

Andrea Morgante
Hairy House, Tokyo
Model
H 18 cm

Prof Sir David Chipperfield CBE RA
Colección Jumex, Mexico City
Wood
H 51 cm

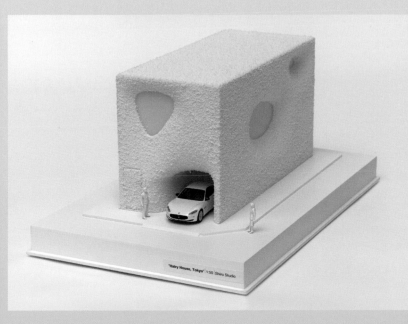

John McAslan + Partners
King's Cross Station, London
Model
H 52 cm

Piers Gough CBE RA
Maggie's Centre, Nottingham
Glazed ceramic
H 28 cm

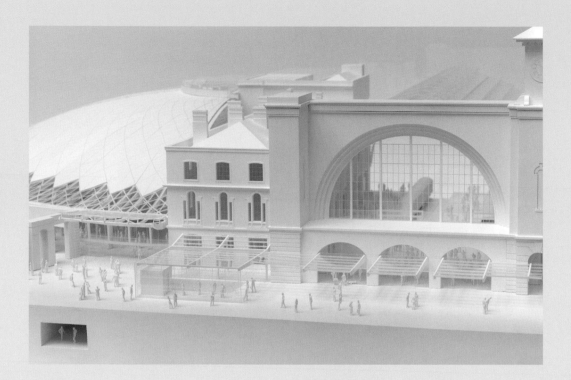

Eric Parry RA
Great Marlborough Street Façade Study
Lacquered wood and Perspex
H 29 cm

Leonard Manasseh OBE RA
House, First Thoughts
Ink
42 × 58 cm

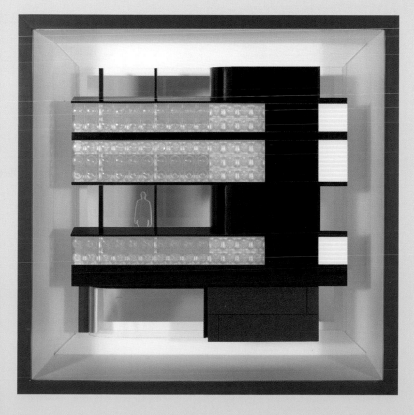

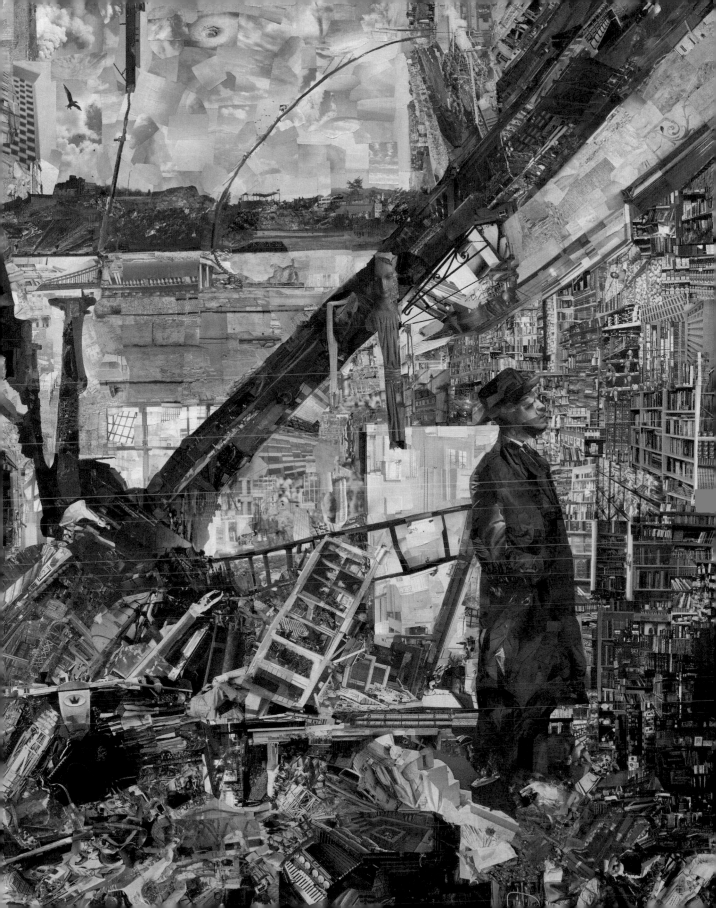

Philip Sutton RA
The Trees Are Flying... They Taste the Spring!
Oil
193 × 127 cm

Anthony Eyton RA
Trevor Dannatt
Oil
93 × 74 cm

Dr David Tindle RA
The Bed with Phone
Egg tempera
124 × 85 cm

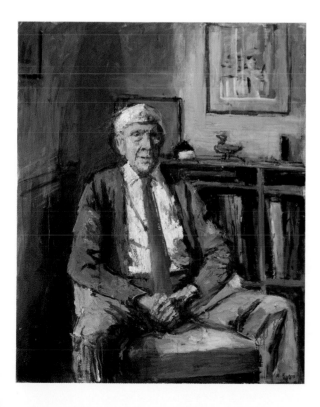

James Crittenden
View from the Studio
Oil
89 × 120 cm

Melissa Scott-Miller
View from an Islington Window
Oil
90 × 90 cm

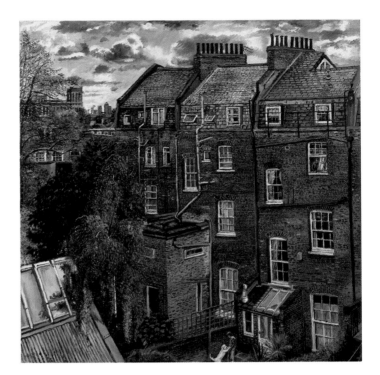

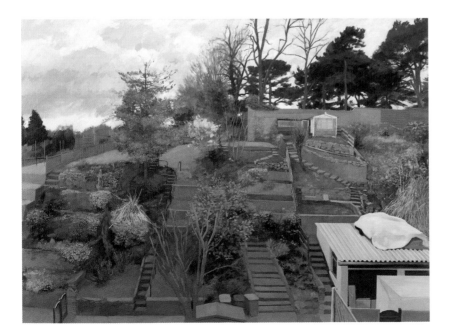

Simon Leahy-Clark
Library II
Collage
170 × 224 cm

Juliette Losq
Marchland
Ink
57 × 75 cm

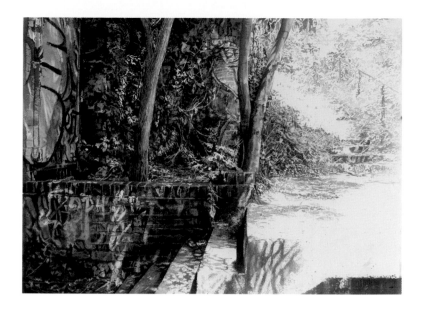

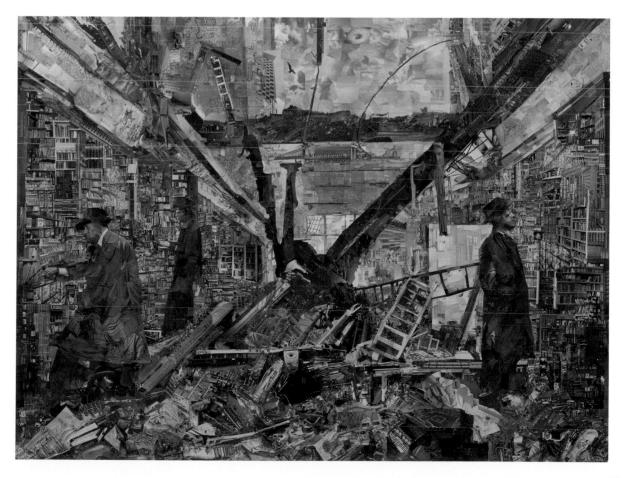

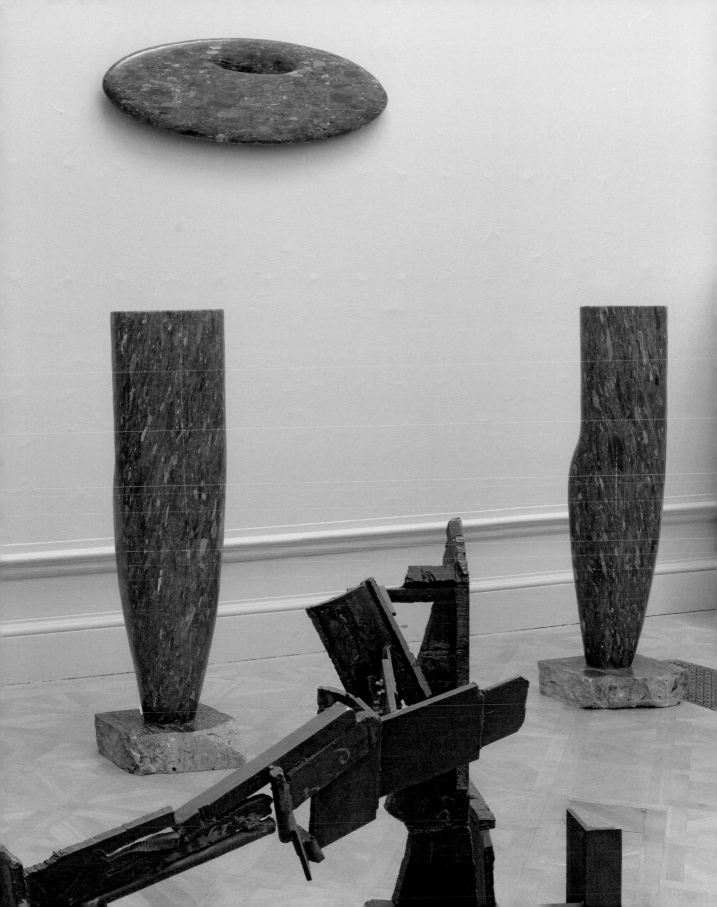

Frank Bowling OBE RA
Journey Along with Marcia Scott
Acrylic
310 × 193 cm

Norman Toynton
Tablet
Mixed media
60 × 60 cm

Prof Dhruva Mistry CBE RA
Something Else – 8
Stainless steel
60 × 48 cm

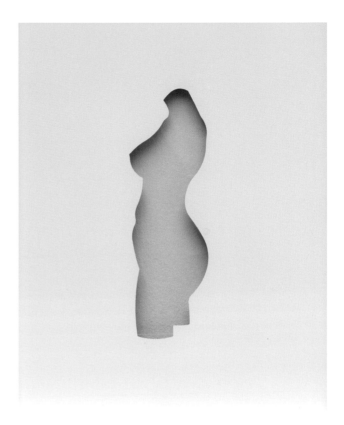

Sir Anthony Caro OM CBE RA
Cubic Piece 'Bassoon'
Bronze
10 × 30 × 30 cm

William Tucker RA
Horse Drawing I
Charcoal
90 × 75 cm

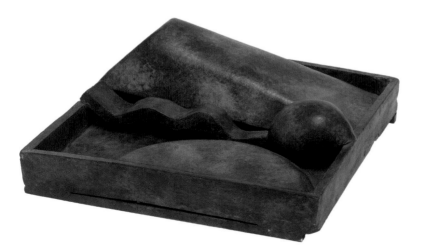

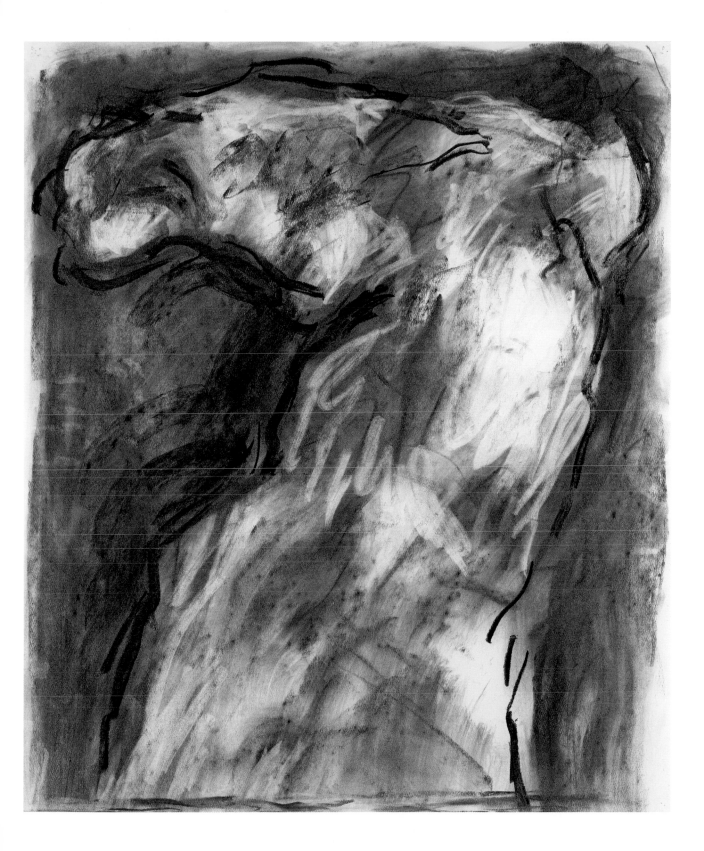

Prof Phillip King CBE PPRA
Blue Slicer
Mixed media
H 30 cm

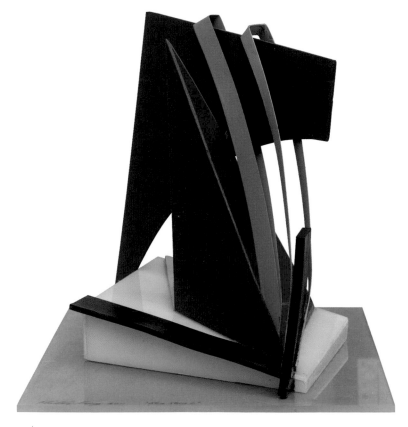

Geoffrey Clarke RA
Portal VII
Cast aluminium
18 × 30 × 4 cm

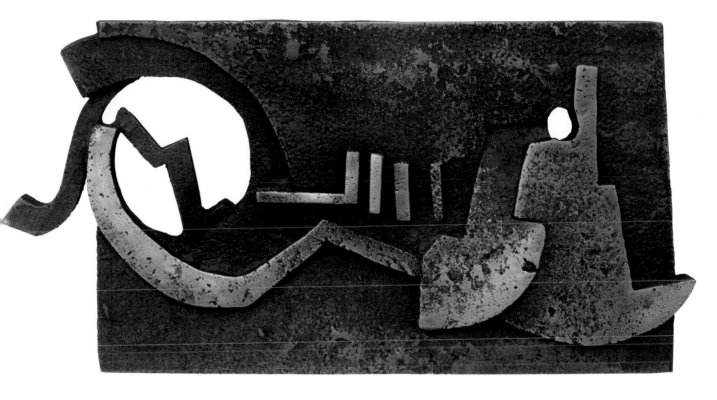

Ivor Abrahams RA
Turtle
Pastel
58 × 49 cm

Simon Brundret
Dog in Bin
Mixed media
H 70 cm

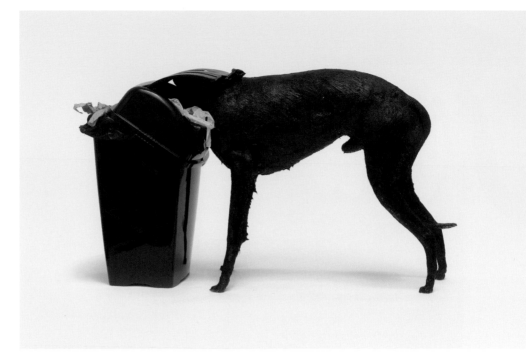

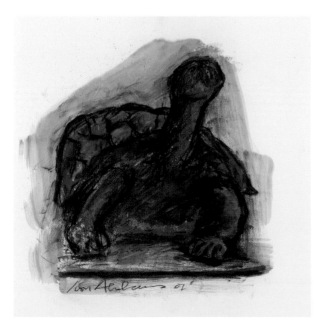

Tim Shaw
What God of Love Inspires Such Hate in the Hearts of Men
Mixed media
H 185 cm

Paul Wager
Requiem (Reflections on War 1914–1918)
Bronze
H 42 cm

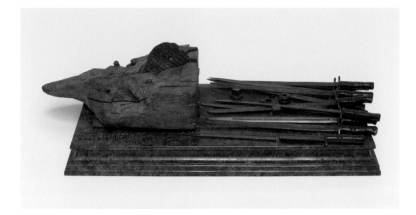

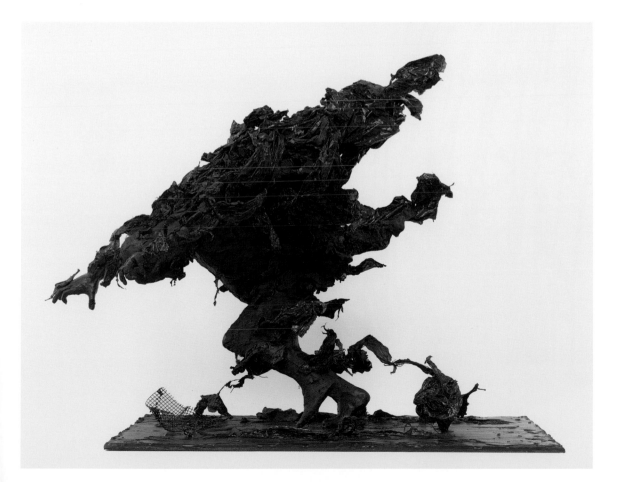

Silvio Živkovié
Are You Ready for Harvest?
Metal
H 80 cm

Prof Bryan Kneale RA
Six Drawings
Ink and wash
Each 47 × 28 cm

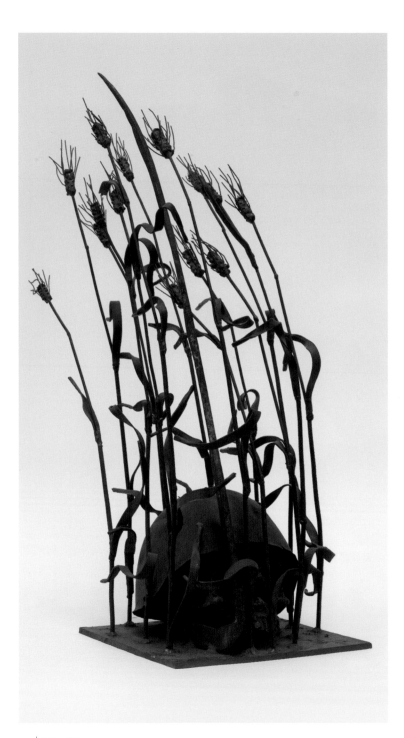

James Butler MBE RA
Study for Rainbow Division
Memorial
Pencil
28 × 20 cm

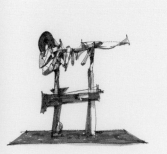

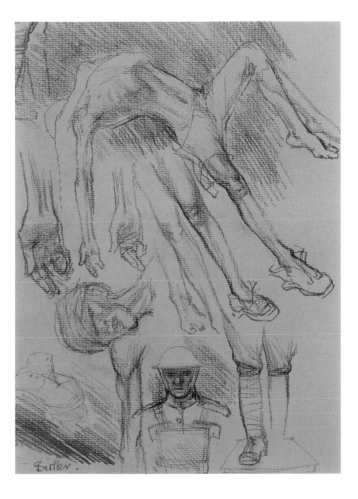

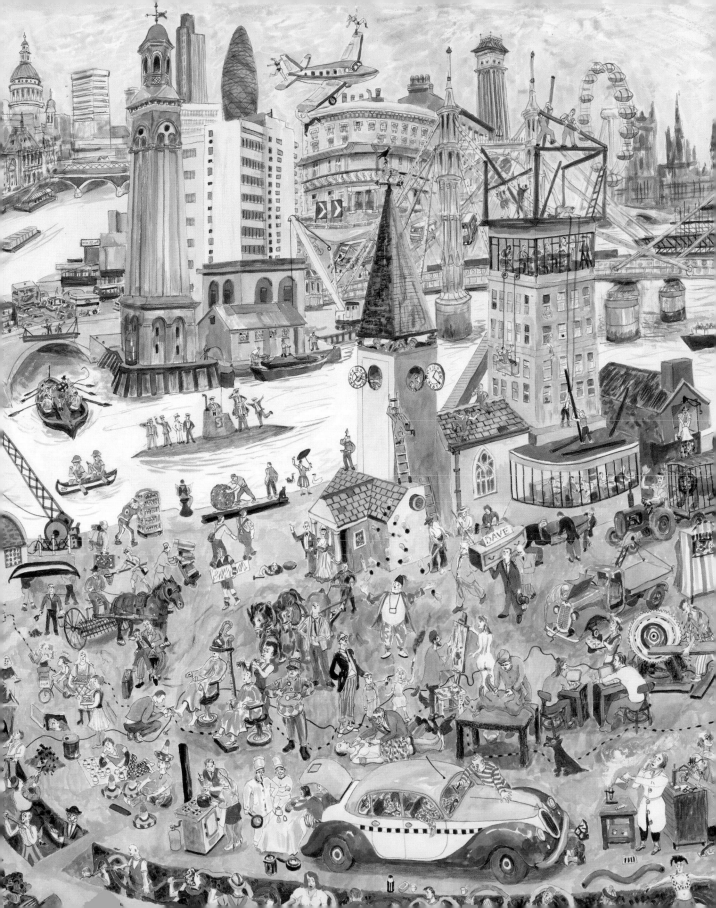

Dr Leonard McComb RA
Garden Trees South London, First Shown
Watercolour
239 × 120 cm

Jeffery Camp RA
Three
Oil
153 × 213 cm

Leonard Rosoman OBE RA
Ship Passing the Window, New York
Gouache
42 × 51 cm

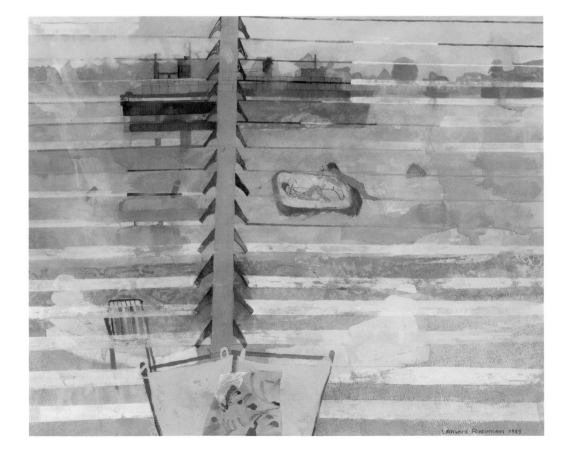

Dr John Bellany CBE RA
Eyemouth
Oil
172 × 172 cm

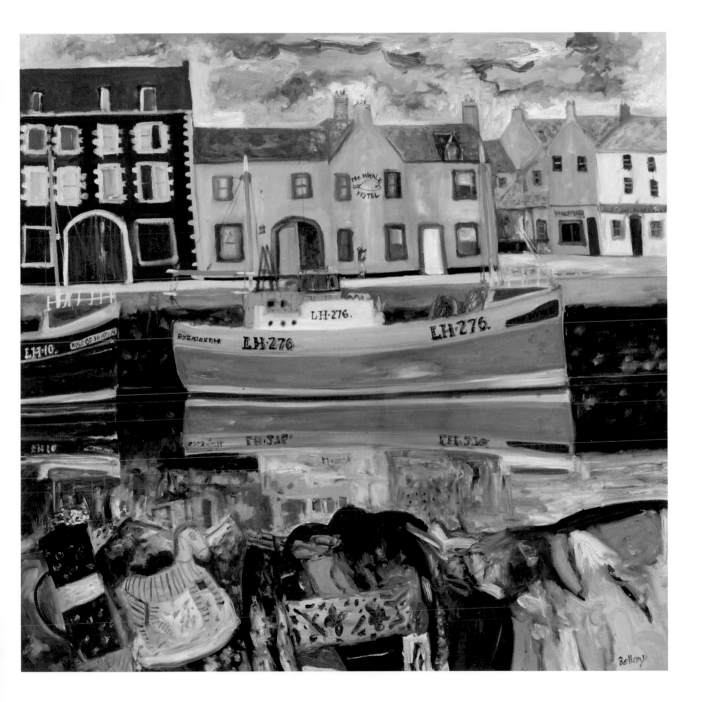

Jock McFadyen
Dagenham
Oil
153 × 338 cm

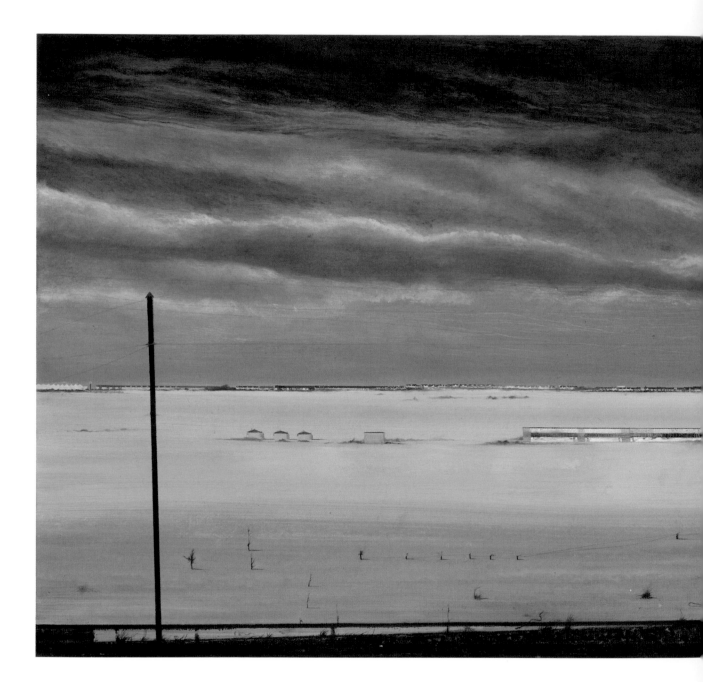

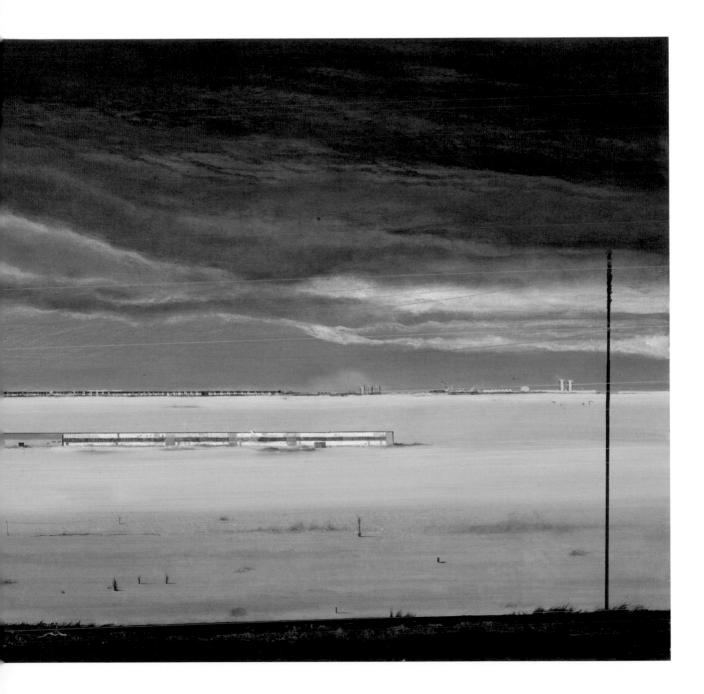

LECTURE
ROOM

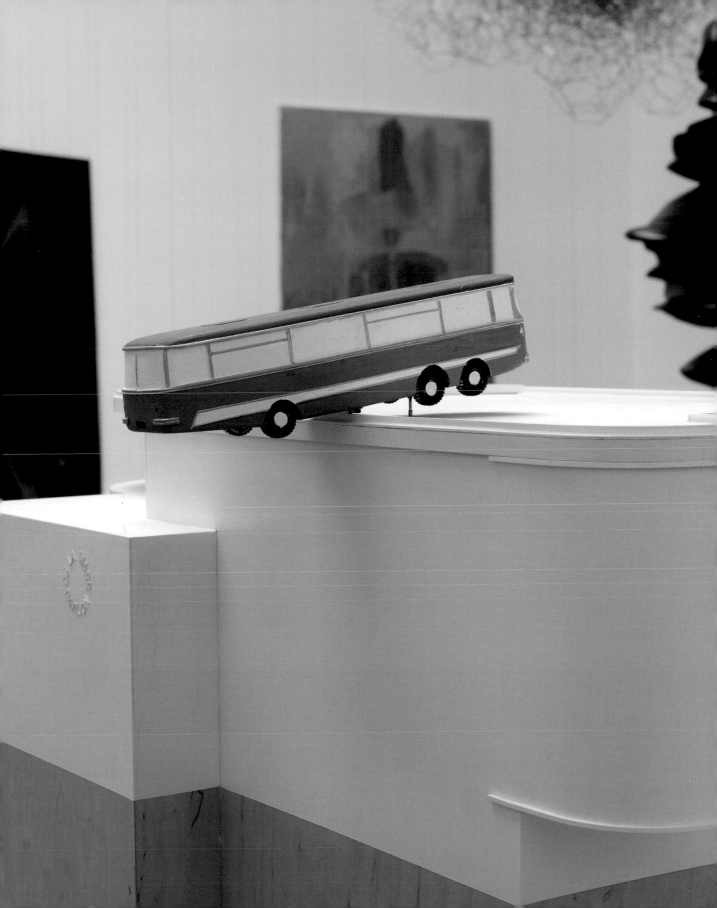

Gillian Wearing RA
Self-portrait as My Mother Jean Gregory
Black and white print
150 × 131 cm

Prof Michael Sandle RA
Encapsulated Submarine
Mixed media
H 28 cm

Tacita Dean RA
The Line of Fate (detail)
Photograph
305 × 98 cm

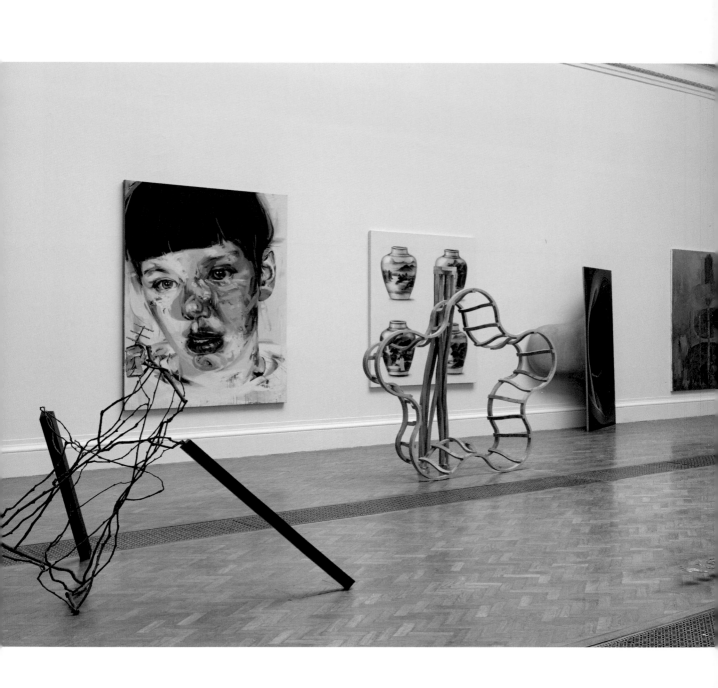

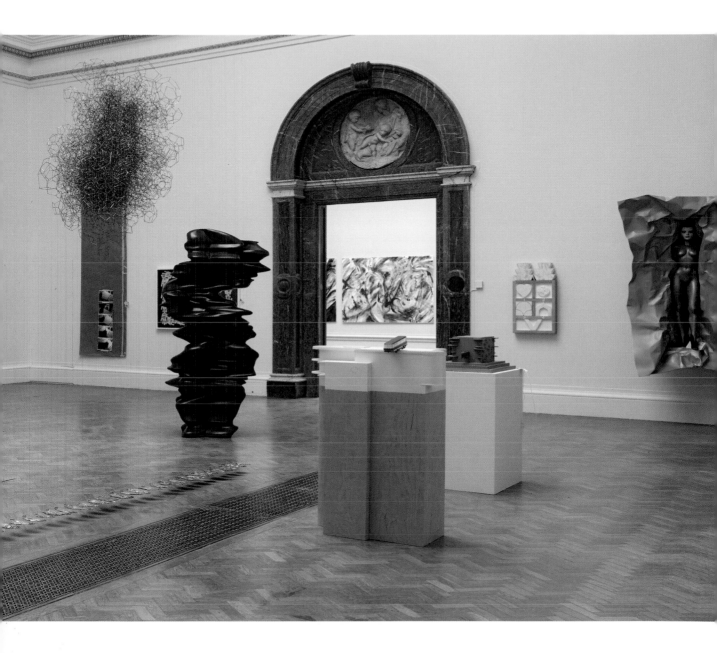

Antony Gormley OBE RA
Drift III
Two-millimetre square-section stainless-steel bar
264 × 175 × 213 cm

Christopher Le Brun RA
Belvedere
Oil
240 × 180 cm

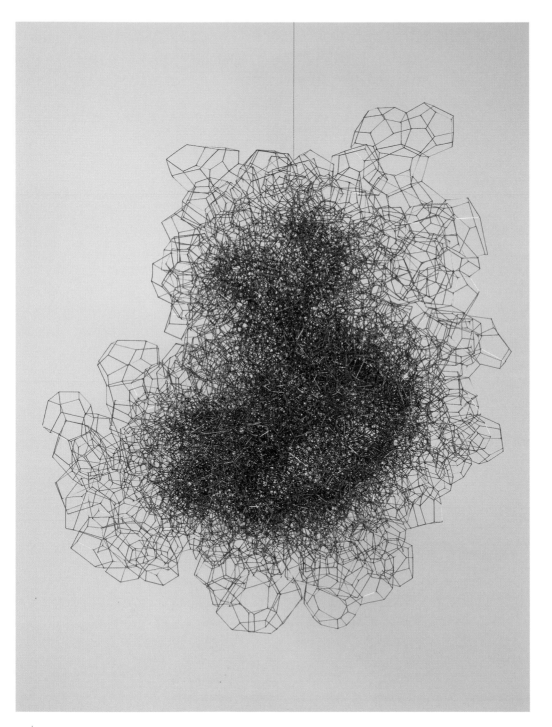

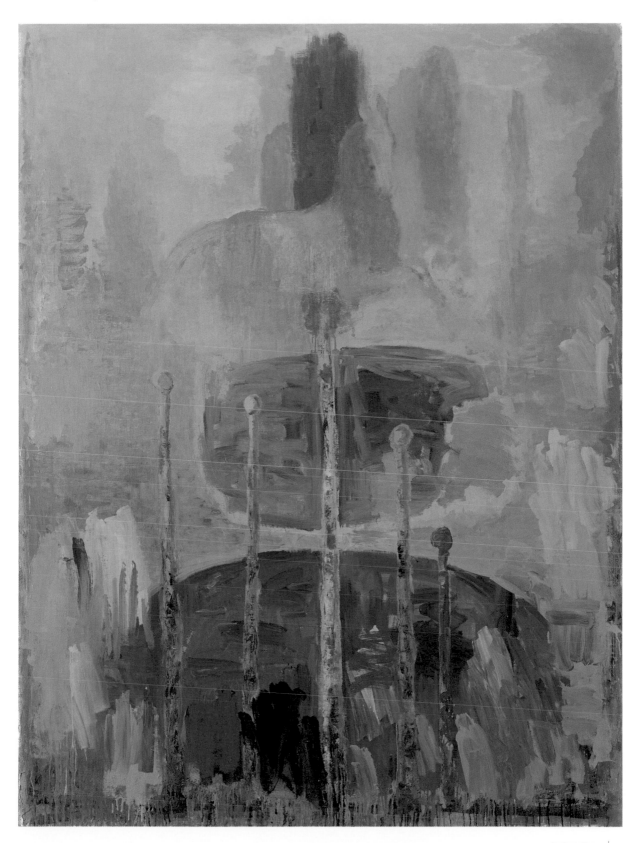

Michael Landy RA
Bathers after Cézanne no. 3
Watercolour and pencil
153 × 209 cm

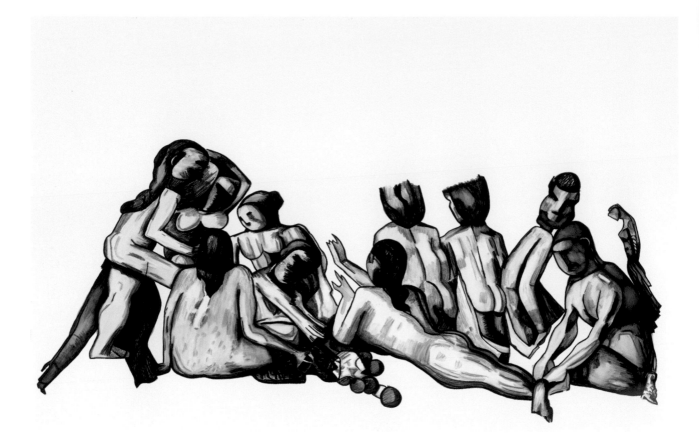

Richard Long RA
Untitled
White china clay on black card
100 × 150 cm

Michael Craig-Martin CBE RA
Fate
Acrylic
200 × 200 cm

Fiona Rae RA
Maybe you can live on the moon in the next century
Oil and acrylic
183 × 150 cm

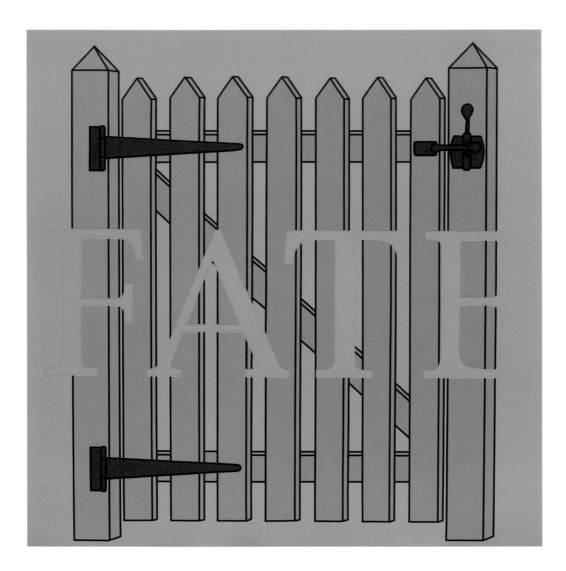

Gary Hume RA
The Cradle
Gloss on aluminium
196 × 198 cm

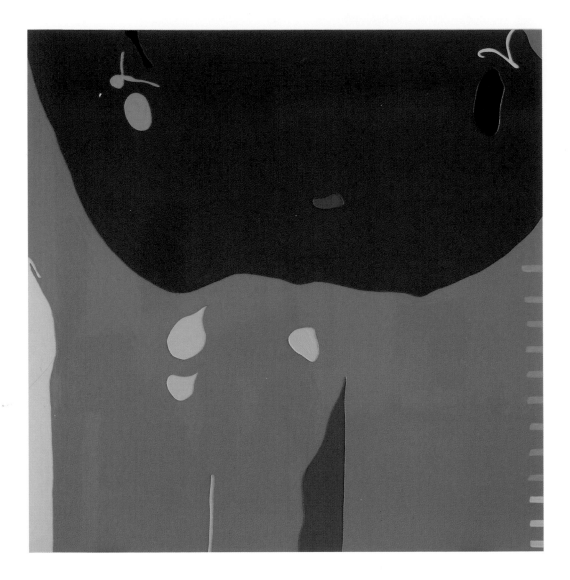

Humphrey Ocean RA
Windscreen
Oil
175 × 229 cm

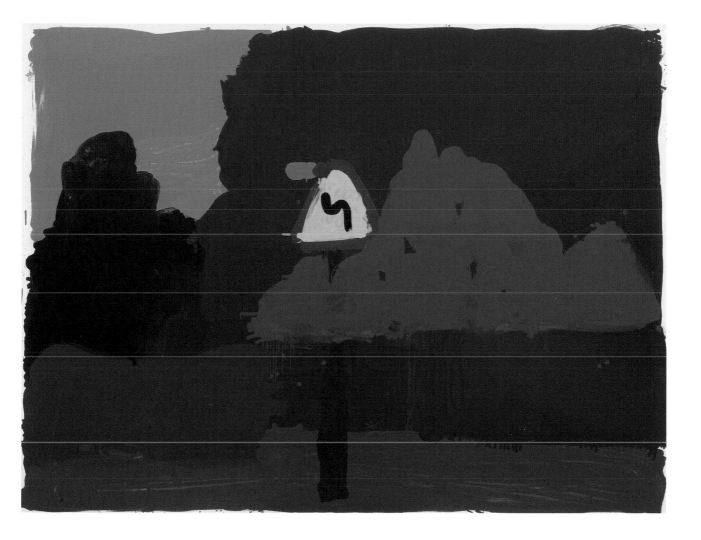

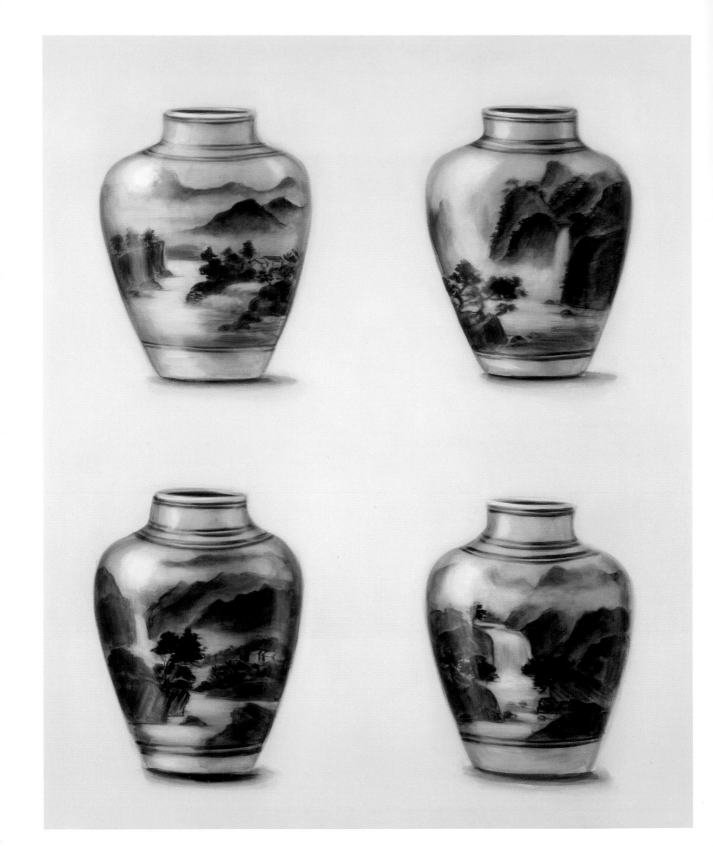

Lisa Milroy RA
Four Vases
Acrylic
203 × 166 cm

David Mach RA
Aquarium
Collage
149 × 149 cm

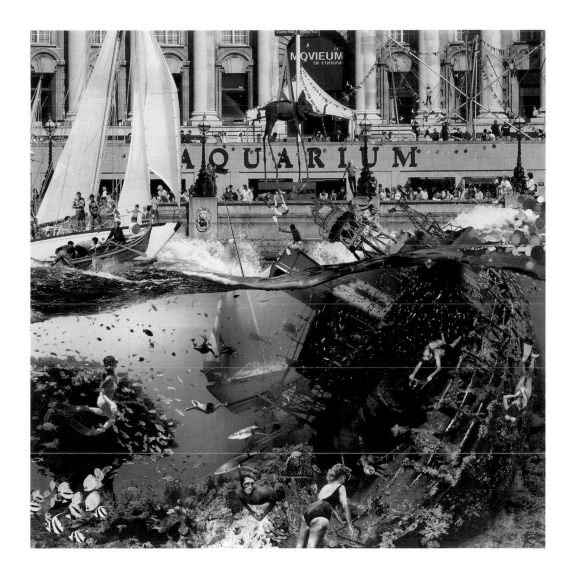

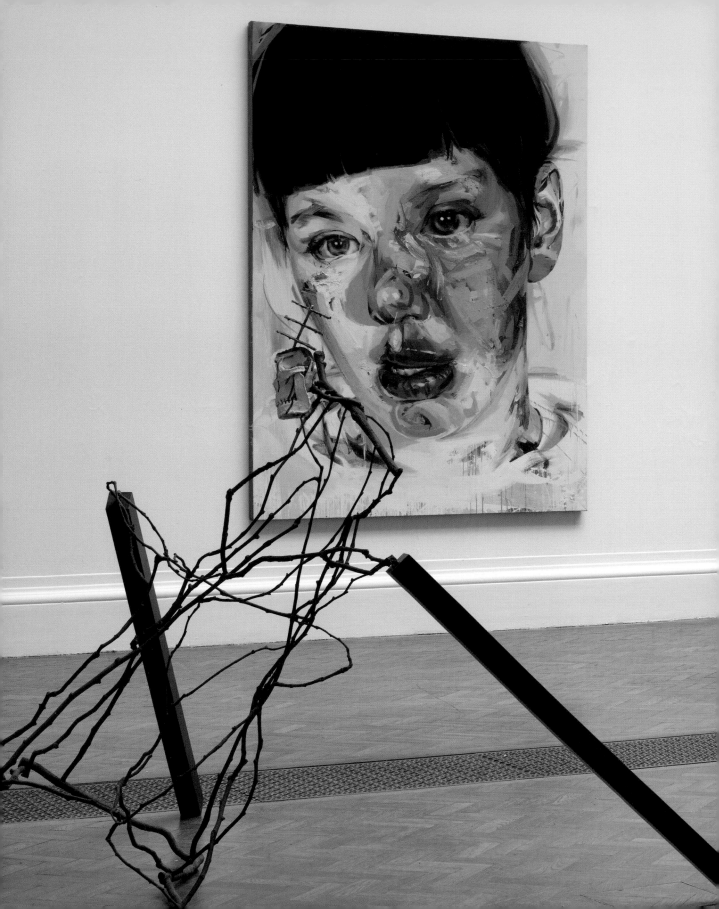

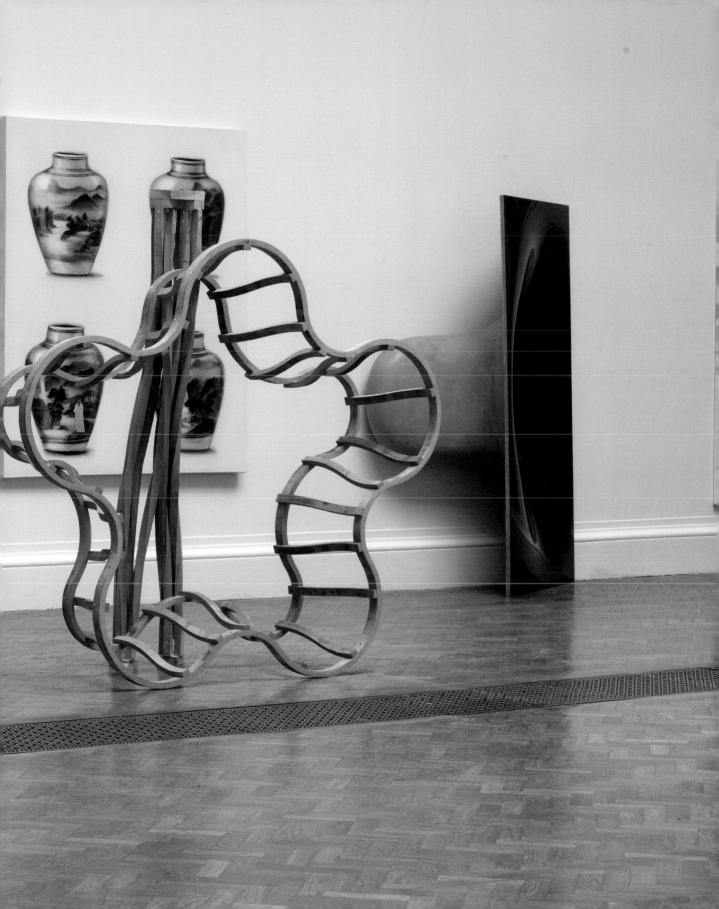

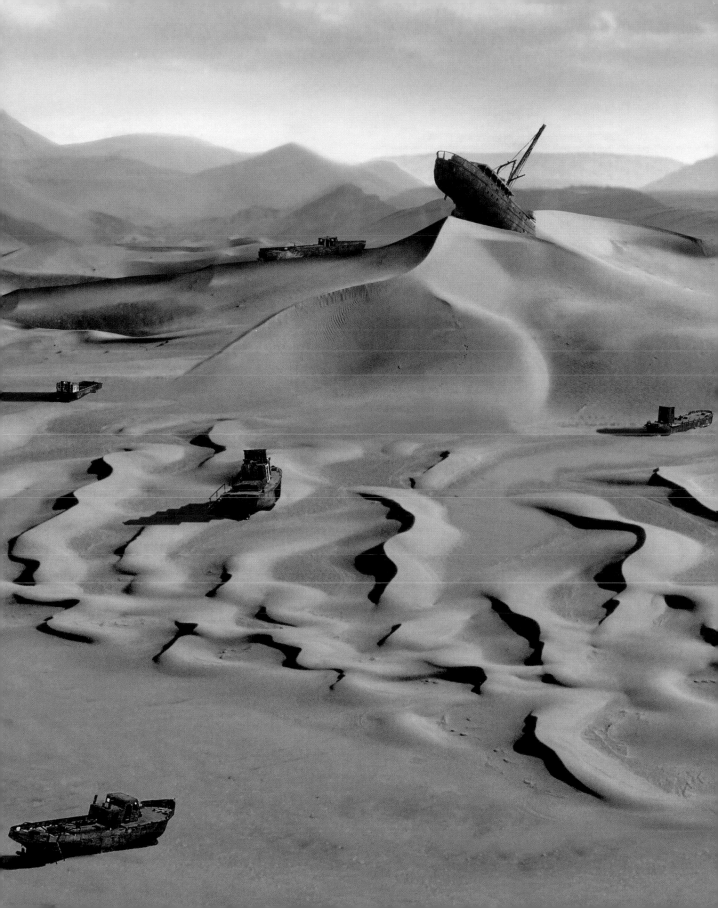

Veronica Smirnoff
Blow
Tempera on wood
90 × 70 cm

Caroline Gorick
The Angelic Guards Ascended, Mute and Sad for Man
Oil
180 × 150 cm

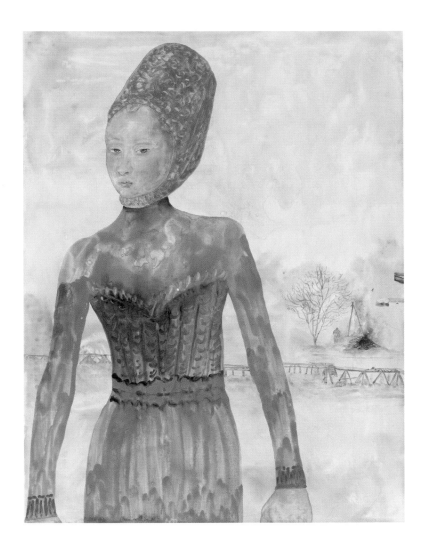

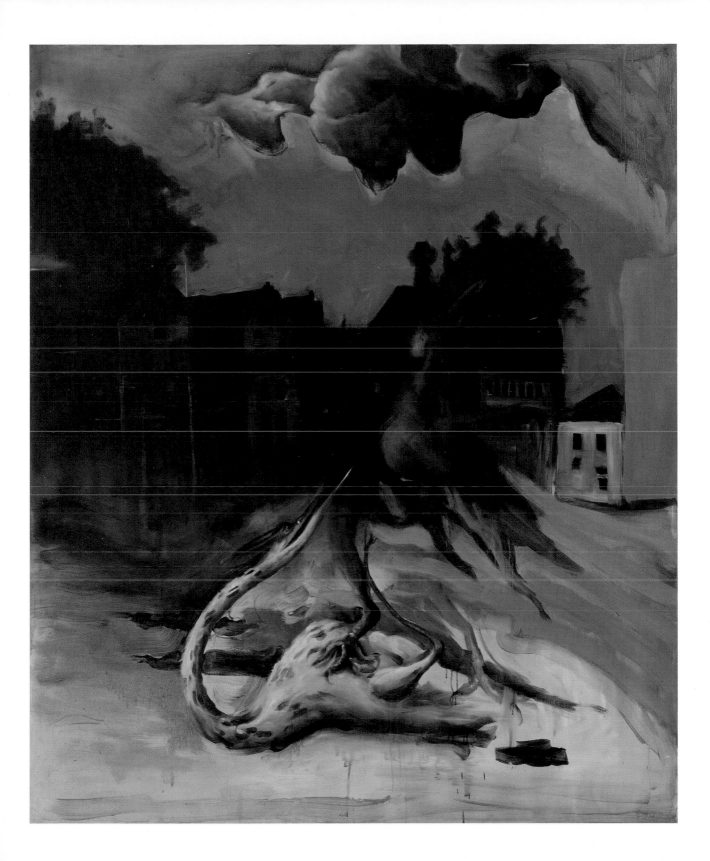

Suzanne Moxhay
Inland Sea
Digital print
69 × 60 cm

Jane Harris
Air Eau
Oil
198 × 163 cm

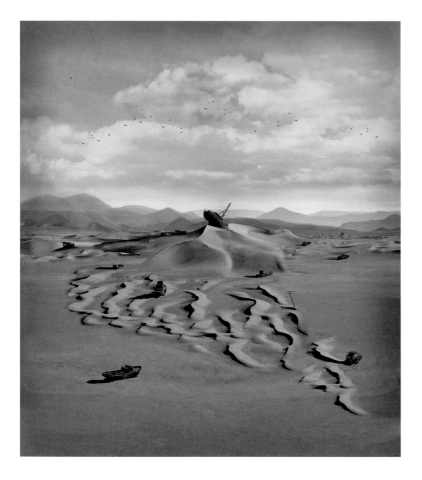

Index

Royal Academy of Arts

The Royal Academy of Arts has a unique position as an independent institution led by eminent artists and architects whose purpose is to promote the creation, enjoyment and appreciation of the visual arts through exhibitions, education and debate. The Royal Academy receives no annual funding via government, and is entirely reliant on self-generated income and charitable support.

You and/or your company can support the Royal Academy of Arts in a number of different ways:

- Almost £60 million has been raised for capital projects, including the Jill and Arthur M Sackler Wing, the restoration of the Main Galleries, the restoration of the John Madejski Fine Rooms, and the provision of better facilities for the display and enjoyment of the Academy's own collections of important works of art and documents charting the history of British art.
- Donations from individuals, trusts, companies and foundations also help support the Academy's internationally renowned exhibition programme, the conservation of the Collections and education projects for schools, families and people with special needs; as well as providing scholarships and bursaries for postgraduate art students in the Royal Academy Schools.
- As a company, you can invest in the Royal Academy through arts sponsorship, corporate membership and corporate entertaining, with specific opportunities that relate to your budgets and marketing or entertaining objectives.

- If you would like to preserve the Academy for future generations, please consider remembering us in your will. Your gift can be a sum of money, a specific item or a share of what is left after you have provided for your family and friends. Any gift, large or small, could help ensure that our work continues in the future.

To find out ways in which individuals can support this work, or a specific aspect of it, please contact the Patrons Office on 020 7300 5885.

To explore ways in which companies, trusts and foundations can become involved in the work of the Academy, please contact the Project Giving Office on 020 7300 5629/5979.

For more information on remembering the Academy in your will, please contact Stacey Edgar on 020 7300 5677 or legacies@royalacademy.org.uk

Membership of the Friends

The Friends of the Royal Academy was founded in 1977 to support and promote the work of the Royal Academy. It is now one of the largest such organisations in the world, with around 90,000 members.

As a Friend you enjoy free entry to every RA exhibition and much more...

- Visit every RA exhibition for free all year long
- Bring one adult family guest and up to four family children under 16 to any exhibition
- See exhibitions before they open to the public at Friends Previews

- Receive the RA Magazine quarterly, delivered to your door
- Access a programme of Friends events throughout the year
- Relax in the Friends Rooms in Burlington House

Why not join today?

- At the Friends desk in the Front Hall
- Online at www.royalacademy.org.uk/friends
- Ring 020 7300 5664 any day of the week

Support the foremost UK organisation for promoting the visual arts and architecture, which receives no regular government funding. Please ask about Gift Aid.

Summer Exhibition Organisers
Natalie Bouloudis
Edith Devaney
Lorna Dryden
Simon Lepp
Katherine Oliver
José da Silva
Paul Sirr
Jessica Smith

Royal Academy Publications
Beatrice Gullström
Carola Krueger
Sophie Oliver
Peter Sawbridge
Nick Tite

Book design: Adam Brown_01.02
Photography: John Bodkin, DawkinsColour
Colour reproduction: DawkinsColour
Printed in Italy by Graphicom

British Library
Cataloguing-in-publication Data
A catalogue record for this book
is available in the British Library

ISBN 978-1-905711-87-1

37pbt

Illustrations

Photographic Acknowledgements

Cover, page 84: The artist. Courtesy Waddington Custot Galleries
Pages 2, 19: © Martin Creed. Courtesy the artist and Hauser & Wirth (page 19: photo Barbora Gerny)
Page 17: Courtesy the artist, Metro Pictures and Sprüth Magers Berlin London
Page 18: Courtesy Jay Joplin, White Cube, London/the artist
Pages 24–5: Courtesy the artist and The Pace Gallery, London
Pages 30–1 (right): Courtesy Galerie Michael Werner, Berlin, Cologne and New York
Page 83 (bottom): Galerie Wolfgang Gmyrek, Dusseldorf, 2006
Page 86: Courtesy the artist and Ingleby Gallery, Edinburgh. Photo John McKenzie
Page 87: © The Artist. Courtesy White Cube, London
Page 130 (bottom left and centre): Hufton + Crow
Page 130 (bottom right): Hélène Binet
Page 166: Courtesy Maureen Paley, London
Page 167 (top): Courtesy the artist and Frith Street Gallery, London
Pages 168–9, 178, 180–1: Courtesy Lisa Milroy and Alan Cristea Gallery
Pages 168–9, 180–1: Courtesy Anish Kapoor and Lisson Gallery, London
Page 170: © The artist. Photo Stephen White, London
Page 175: © Fiona Rae, courtesy The Pace Gallery, London. Photo Kerry Ryan McFate, courtesy The Pace Gallery, London
Page 176: © Gary Hume. Photo Stephen White, London